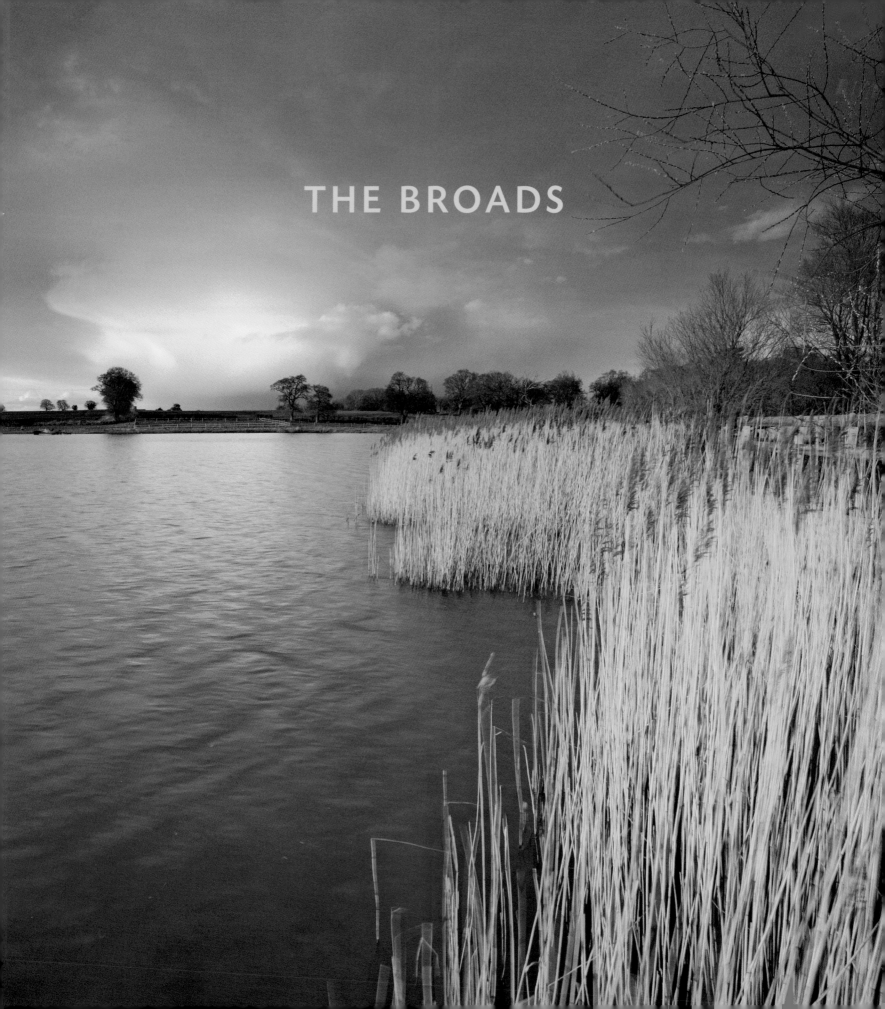

THE BROADS

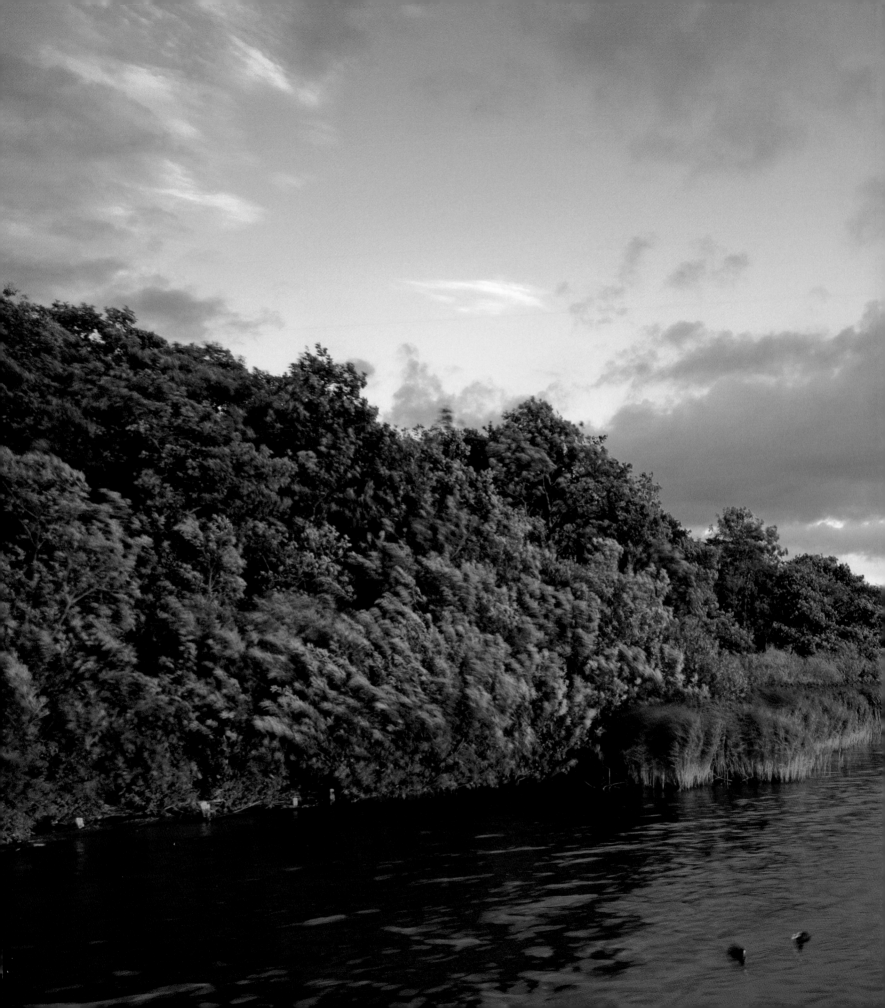

THE BROADS
WATERWAYS OF NORFOLK AND SUFFOLK

Jon Gibbs

F

FRANCES LINCOLN LIMITED

PUBLISHERS

*This book is dedicated to Stef,
Ione, Jasmine and Cameron*

Frances Lincoln Limited
4 Torriano Mews
Torriano Avenue
London NW5 2RZ
www.franceslincoln.com

The Broads
Copyright © Frances Lincoln Limited 2009
Text and photographs © Jon Gibbs 2009

First Frances Lincoln edition: 2009

A catalogue record for this book is available from the
British Library.

ISBN: 978-0-7112-2981-5

Printed and bound in Singapore

9 8 7 6 5 4 3 2 1

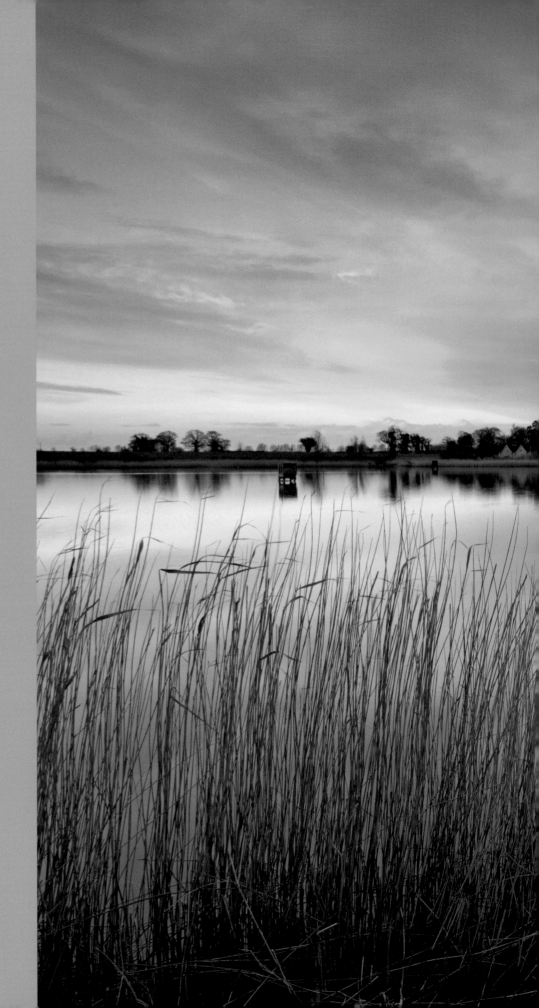

HALF TITLE Hardley Flood beside the River Chet in
dramatic evening light.

TITLE PAGE Beautiful late evening light at Filby Broad.

RIGHT Hardley Flood under a beautiful twilight sky.

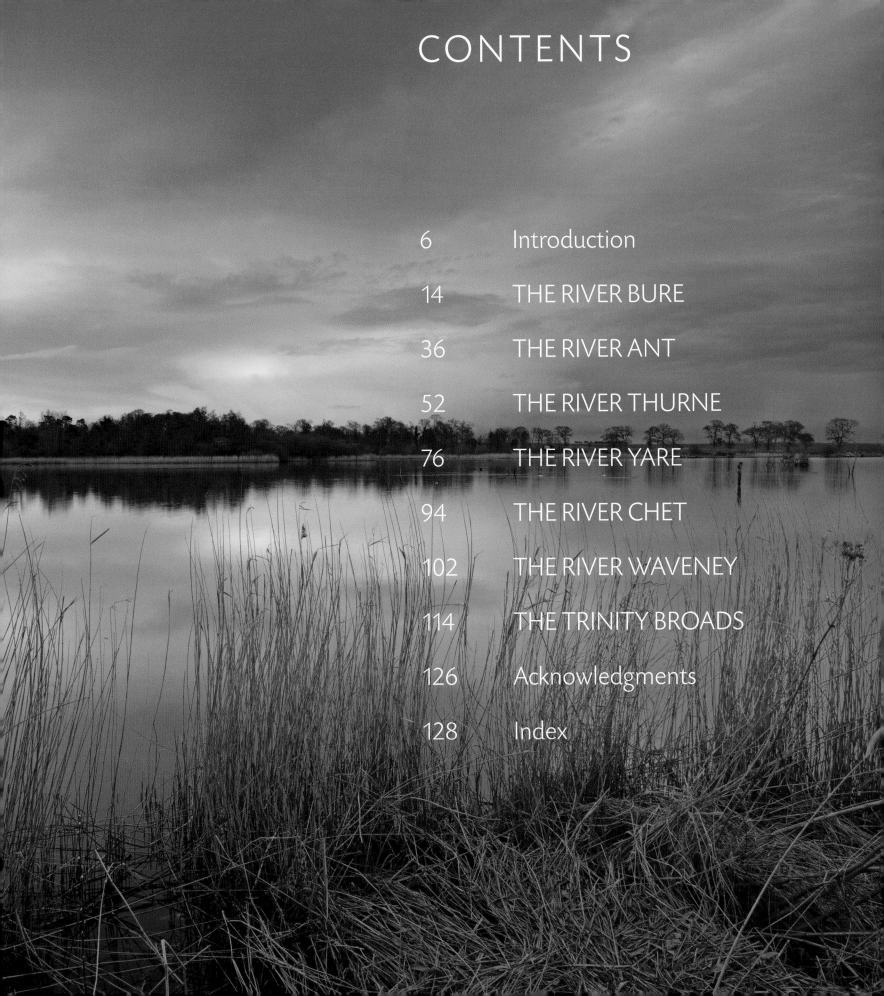

CONTENTS

INTRODUCTION

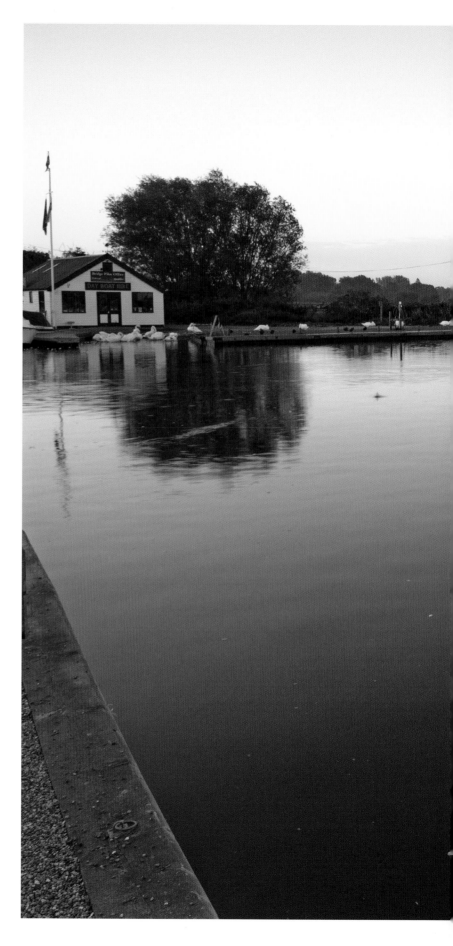

The unmistakable sight of a barn owl flying low over the marshes, the fleeting glimpse of fast-moving electric blue – a kingfisher perhaps? – the rustling reeds as a water deer's peace is shattered by my intrusion into its natural habitat, mirror-calm water reflecting a wide open sky and a young girl on the front of a boat with arms outstretched doing her best Kate Winslet impression from the film *Titanic* for my lens!

These are all wonderful memories and experiences of a part of the world that I have come to love and respect. In truth, however, I hadn't always felt that way. As a young adult I could never envisage how people could get so much enjoyment from their holidays cruising up and down the rivers; in fact I can remember mocking the Broads as a holiday destination.

I suppose it is the passing of time and a re-awakening of a love for photography that had first reared its head in my mid-teens that has helped to change my views. As a photographer I see things very differently now.

It is true to say that the Broads is not a dramatic landscape but it makes up for this lack of drama with an understated beauty and a sense of peace. When I walk the riverbanks or make my way around one of the many nature reserves I feel far removed from the stresses and strains of modern life.

What is so easy to forget, though, when you are out and about surrounded by nature, is that the Broadland landscape was largely shaped by man. Medieval peat diggings left the land scattered with large holes, but these holes eventually filled with water.

Dawn at Potter Heigham beside the River Thurne.

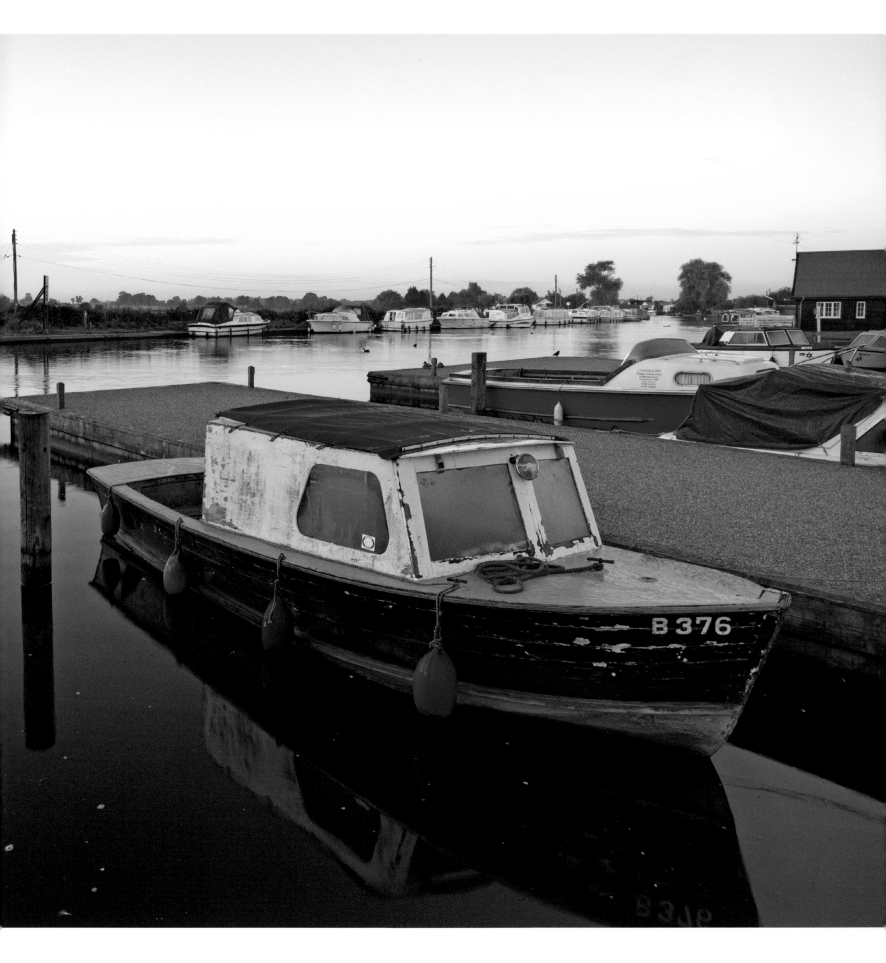

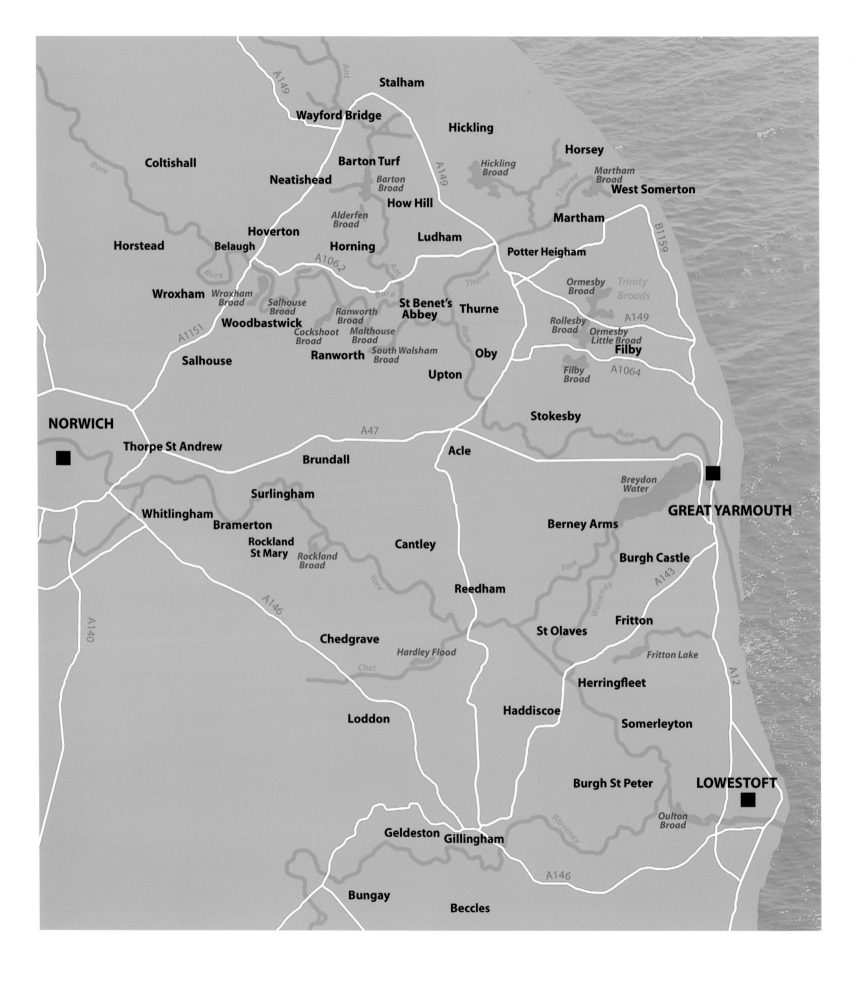

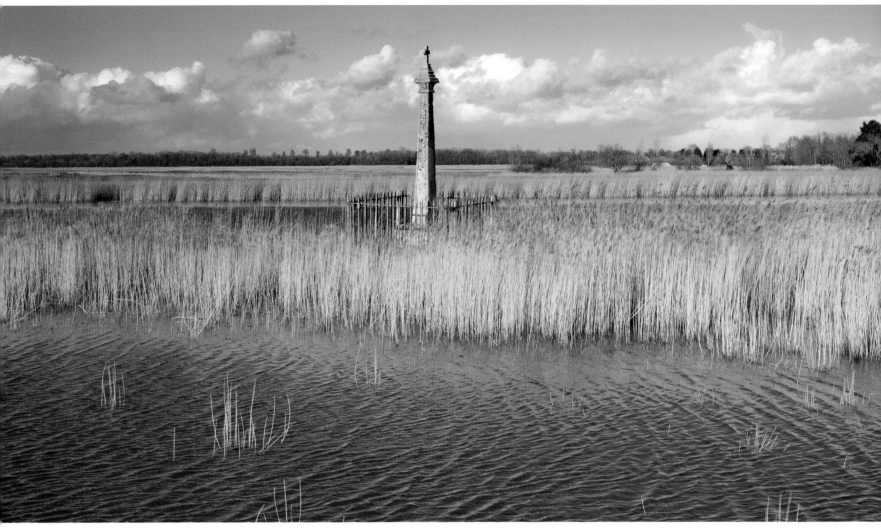

Hardley Cross beside the River Yare near Reedham.

The reasons for this were that peat's importance was reduced by alternative fuels such as wood, the labour force was decimated by the horrors of Black Death and plagues and the weather had brought widespread flooding to the area. Further down the timeline drainage channels were constructed to alleviate the land from flooding and dykes were cut to open up trade routes. The area we know today as the Broads had started to take shape.

Nature had taken its course as well and the Broads became a haven for wildlife and were studied as early as the 1600s by Sir Thomas Browne.

The next major change to the Broadland landscape was the introduction of drainage mills that pumped out the flooded water from the agricultural land. There are numerous examples of these lovely buildings alongside the rivers and on the marshes, some beautifully preserved and some shadows of their former selves.

As the city of Norwich developed as a sea port and used its connections to the coastal towns of Great Yarmouth and Lowestoft, the 'wherry' became a very familiar site on the waterways, carrying all manor of goods between the ports and villages. Unfortunately only a few of these beautiful craft survive, but it is a glorious sight to see one of the preserved examples in full sail gliding along the Broads.

The development of the railway system brought about further change. The Broads network was no longer used for

OVERLEAF: Whitlingham Great Broad near the city of Norwich on a summer morning.

9

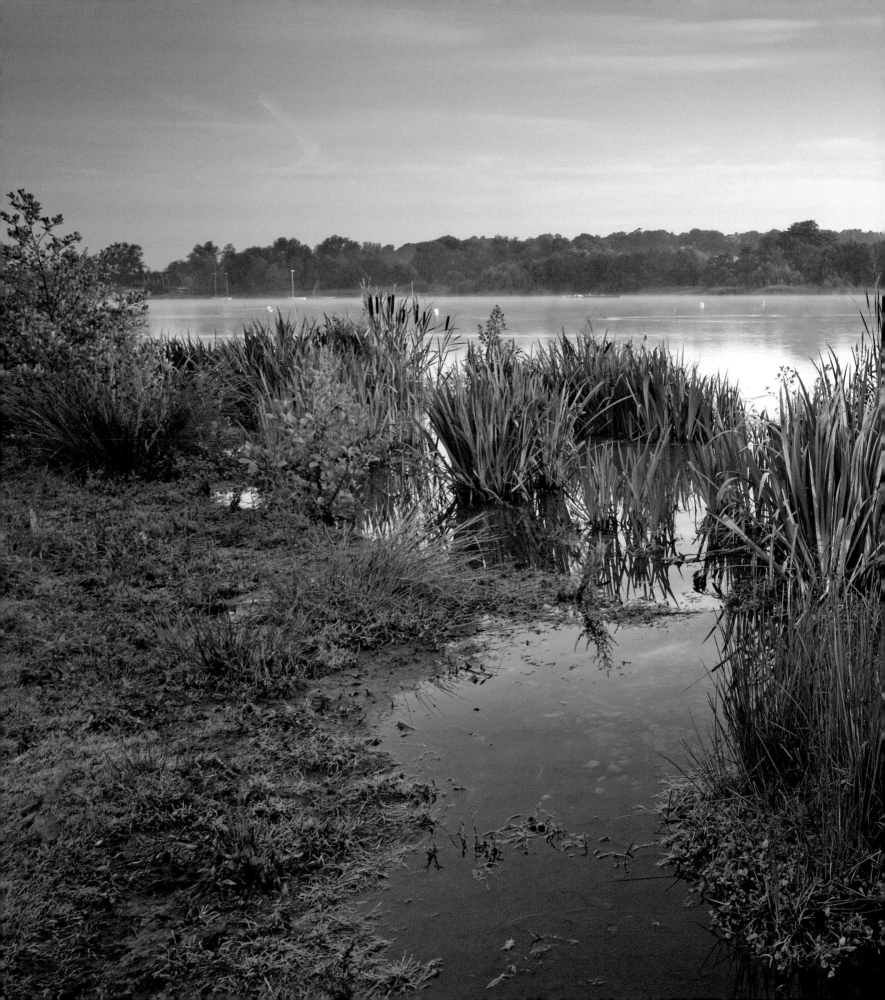

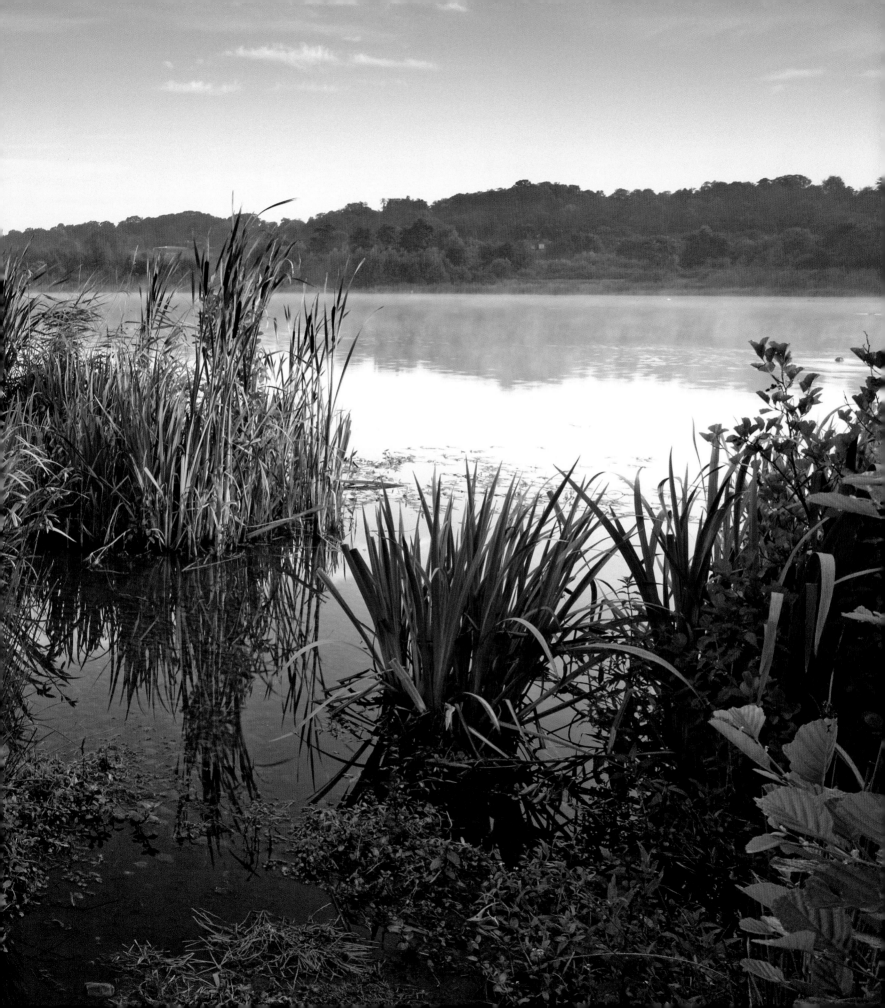

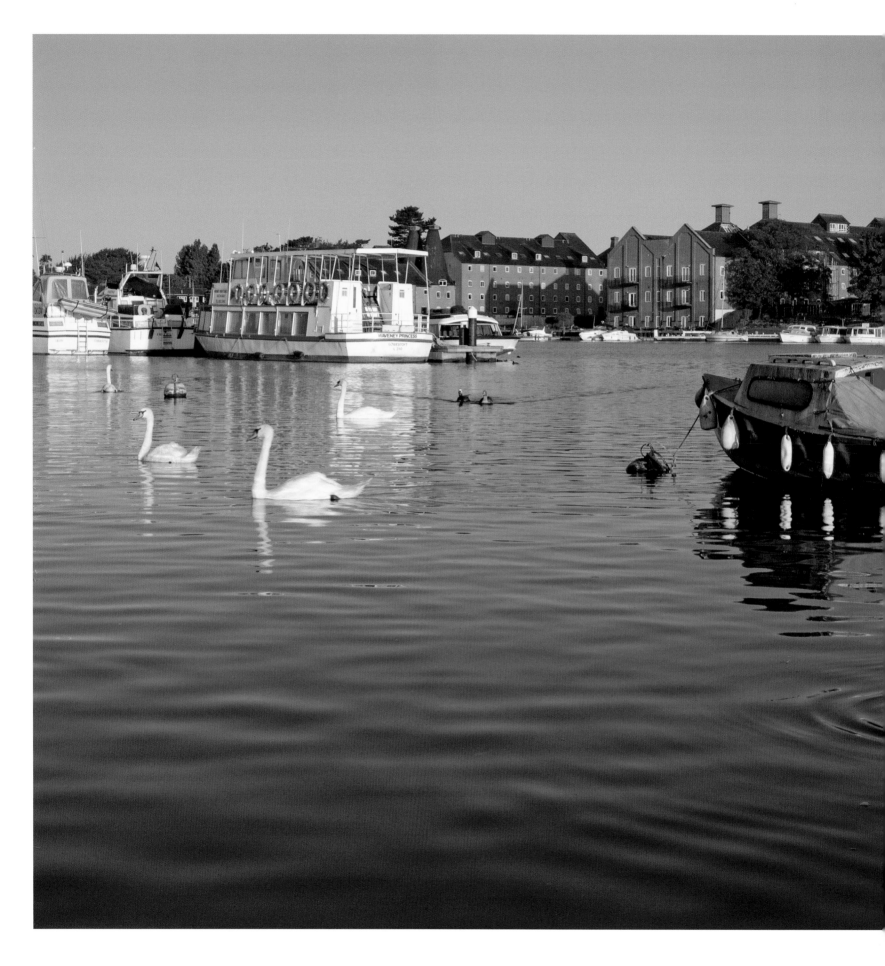

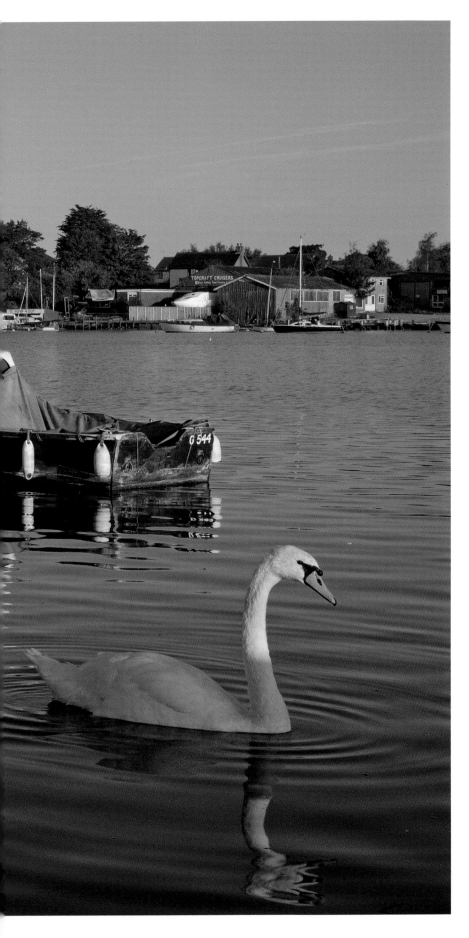

trading to the same degree as when the rivers were 'thick with huge black sails', as in the heyday of the wherry.

The holiday industry associated with the Broads began in the late 1800s when the rivers became a destination for boating adventure holidays for the upper classes. At the same time, John Loynes founded the first Broadland boat-hire firm and the seeds for today's tourist industry were put in place.

Today the Broads holiday industry is still incredibly busy, and for a few weeks in the height of the summer season you could be forgiven for thinking that peace would never return to the rivers as the ubiquitous Broads cruisers pass by in great number and the rivers are full of all types of craft 'messing about on the river'.

Before long, though, the season is over and you could walk for miles along the riverbanks with only the sound of the wildlife and a gentle wind rustling through the reeds for company.

In undertaking this project to photograph the Broads for this book I had a couple of dilemmas. The geography of the Broads makes it difficult to arrange the sites and locations in a working order, so to speak.

What I have done is used the rivers as my basis for each part of the book. Pictures of landlocked Broads or the countryside are included in the part of the book that they are closest to geographically. Those familiar with the Broads will also recognise that I have placed the images in the book going in an upriver order. My journeys to photograph the Broadland landscape begin in my home town of Great Yarmouth where all the three main rivers of the Broads converge so it is just my way of seeing things.

I also decided very early on to only take pictures of accessible views and not to take any images from boats so all the images you see in these pages can be visited by foot.

It has been a pleasure to visit so many new places that were on my doorstep and photograph them in so many different moods, whilst discovering a little more about this special landscape. I hope you enjoy the images.

Jon Gibbs

Oulton Broad, known as the Southern Gateway to the Broads.

THE RIVER BURE

The River Bure flows into the River Yare (which in turn flows into the North Sea) at Great Yarmouth and is navigable from Coltishall, a distance of 31½ miles. It is one of the three main rivers of the Broads and has two tributaries: the River Ant and River Thurne.

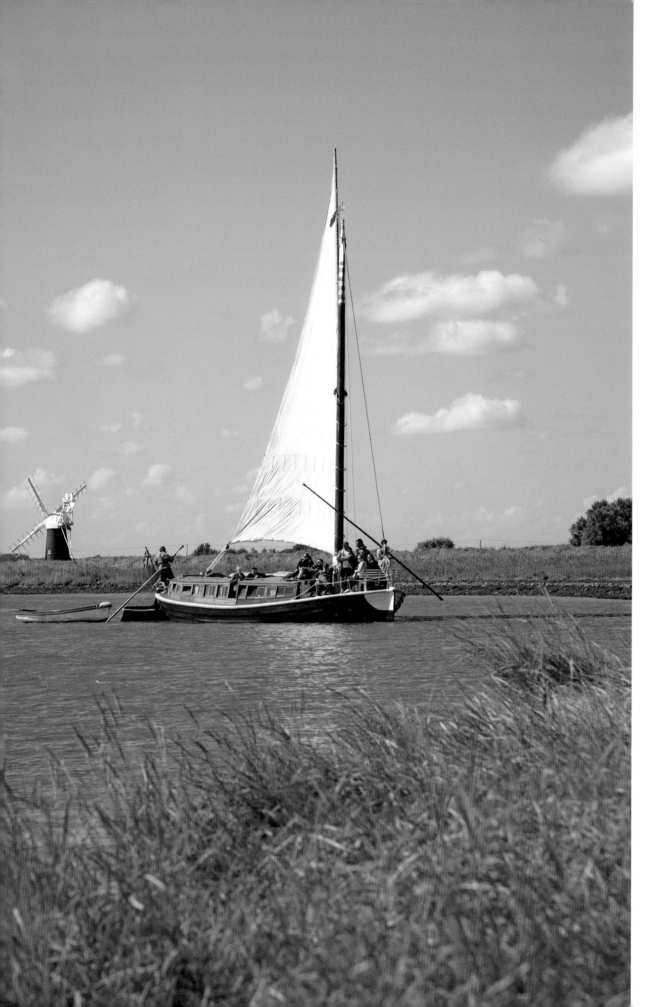

The pleasure wherry *Hathor* near Ashtree Mill on the outskirts of Great Yarmouth. These beautiful traditional craft, of which only seven remain, have a busy summer period on day trips along the rivers of the Broads.

Hathor was built for the Colman family of Colman's Mustard fame and is decked out in Egyptian motifs.

15

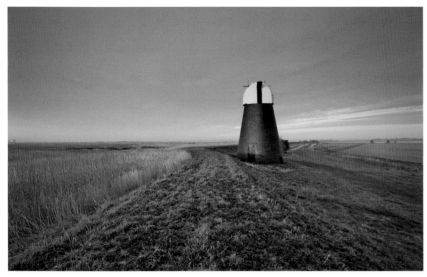

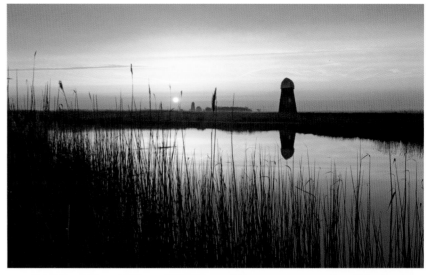

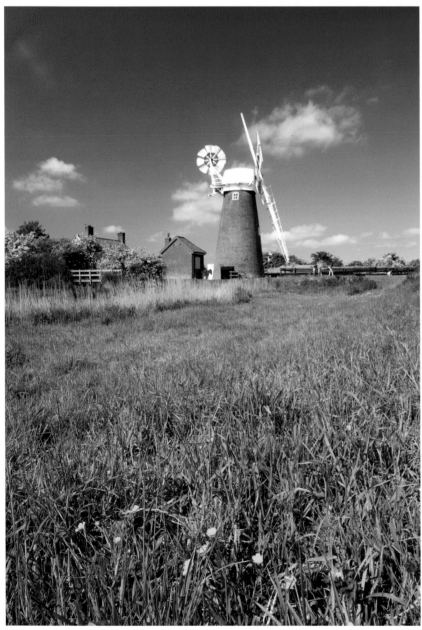

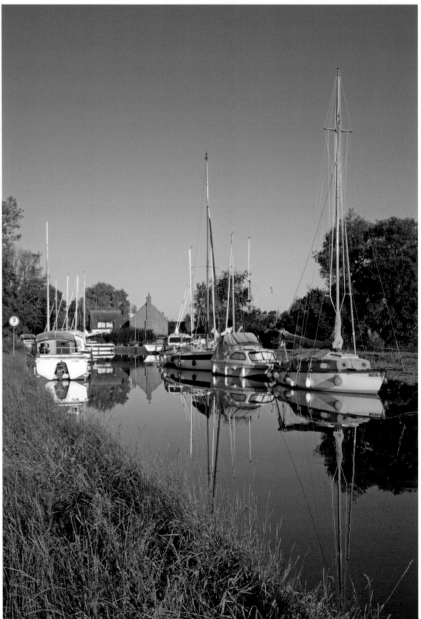

OPPOSITE

ABOVE LEFT Early morning light at Runham Drainage Mill. At Runham you can view four mills beside the river but unfortunately none of these has its sails any more.

ABOVE RIGHT Looking back towards Great Yarmouth from Runham, the silhouetted shapes of Runham Swim and Five Mile House drainage mills stand out against a beautiful sunrise.

BELOW LEFT Stracey Arms is the first mooring along the river from Great Yarmouth. In summer this is a very popular place for Broads craft to stop for a visit to Stracey Arms Mill. There is a small museum here dedicated to the drainage mills, which are such a feature of the Broadland landscape.

BELOW RIGHT A mile away from Acle Bridge is Upton Dyke, which detours from the river along a half-mile channel to the staithe at the village of Upton.

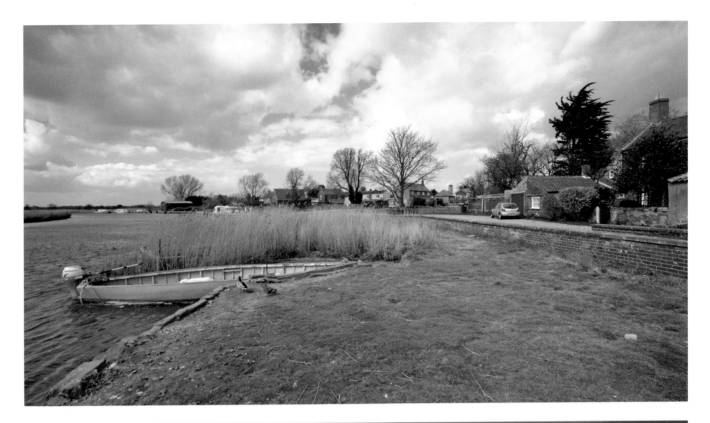

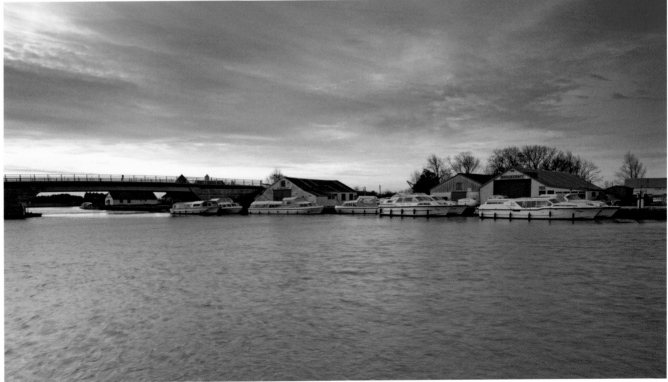

TOP Stokesby is a delightful village and is a very popular spot for mooring during the holiday season. The Ferry Inn, named after the ferry that used to cross the Bure here to take people to the market at nearby Acle, is one of the most popular Broadland pubs.

ABOVE Modern Broads cruisers await the return of the holiday season next to Acle Bridge beneath a dramatic sky. The bridge here was rebuilt in 1997 after an earlier bridge built in the 1930s began to subside due to the increasingly heavy traffic.

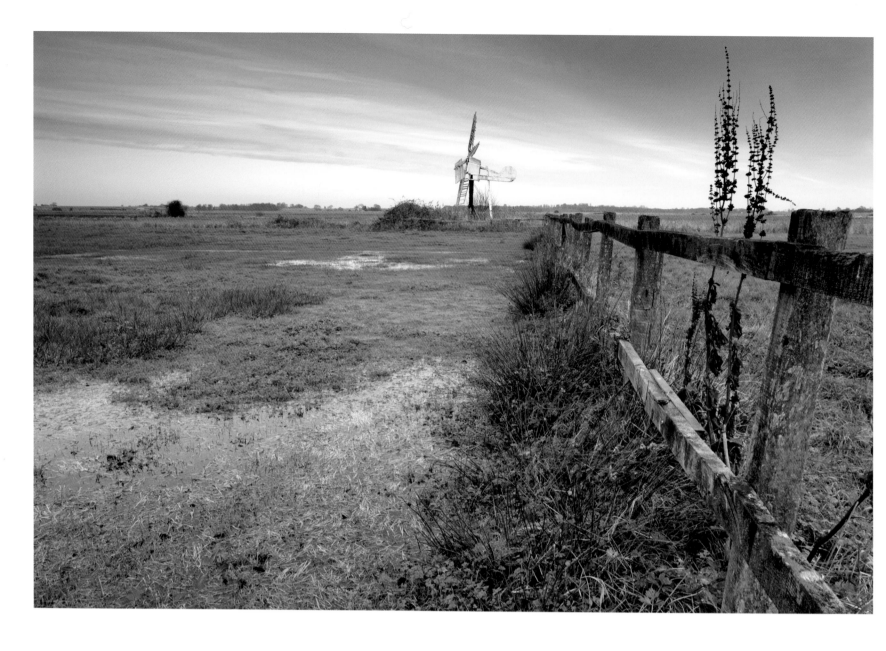

Beside Upton Dyke is Palmer's Drainage Mill, which is known as a hollow post mill: a rarity on the Broads, being one of only two surviving examples. This mill was resited from its original position nearer to Acle.

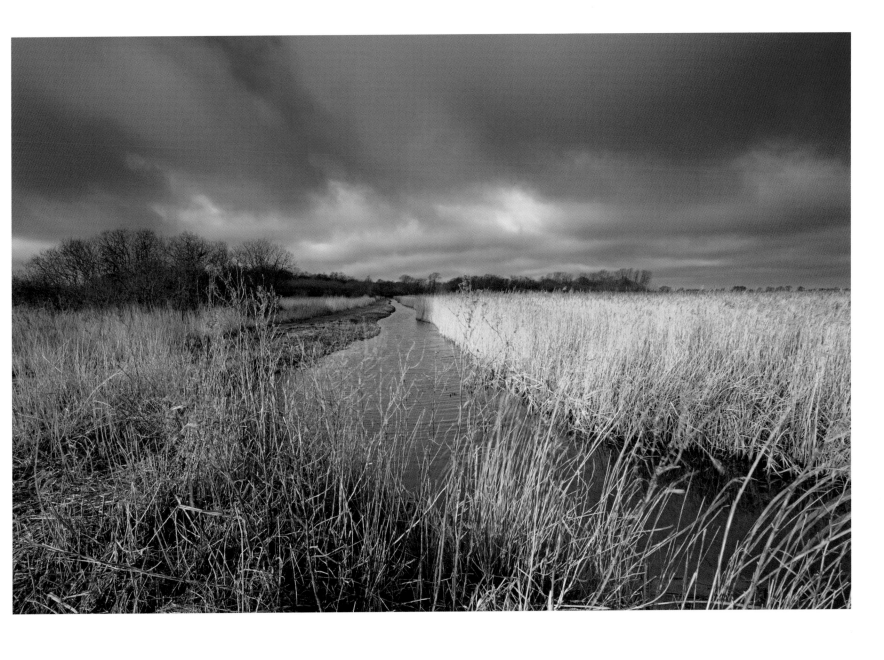

Upton Fen Nature Reserve encompasses so many examples of the natural environments associated with the Broads. This lovely reserve has examples of alder carr woodlands, fens, open water, grazing marshes and as shown in this example reed fringed dykes pictured beneath a stormy sky.

Norfolk is often famed for its wide open skies, and here at Upton Nature Reserve the view across the grazing marshes looking towards Oby and Thurne illustrates the flatness of the land and the wide views that are such a feature of the Broadland landscape.

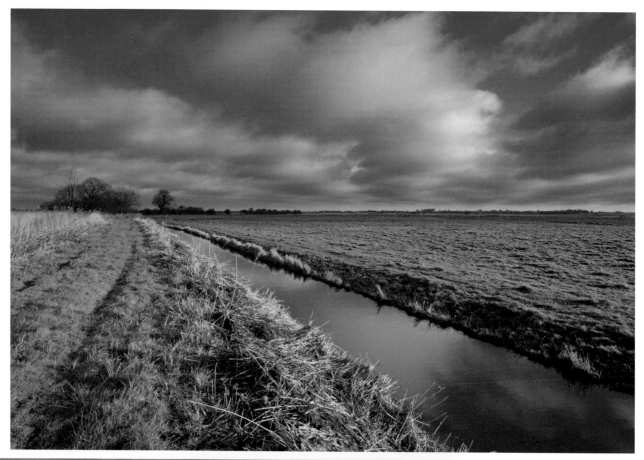

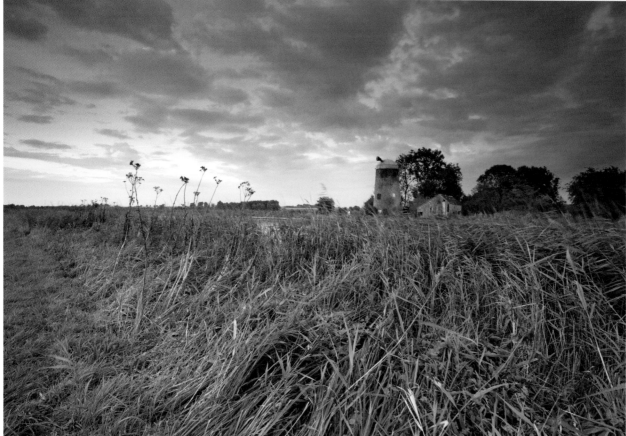

Oby Mill pictured beneath a dramatic sky.

The datestone on this mill reads 1753 which suggests that this is the oldest mill in Broadland. It is also a Grade II listed building. At the time of writing, the mill was about to go under auction and hopefully one day soon it will be restored faithfully to its former glory.

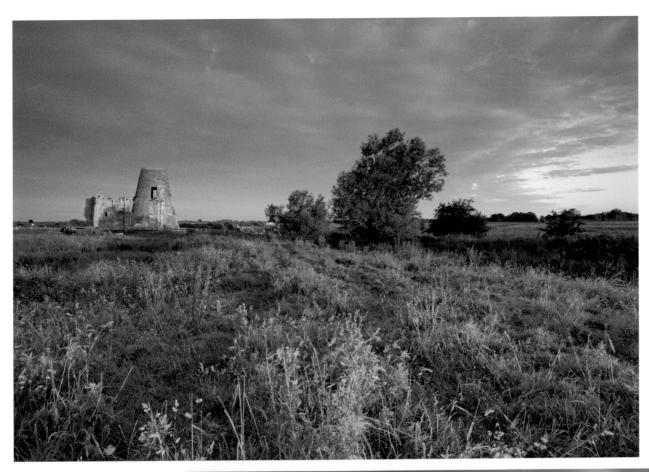

St Benet's Abbey is one of the most distinctive sights in the Broads. Within the ruins of its gatehouse there are the remains of an eighteenth-century drainage mill.

It is believed that the use of this site for religious purposes dates back to the 800s. The gatehouse depicted here dates from the fourteenth century and the whole abbey complex in its heyday must have been an impressive sight in its position on the banks of the Bure.

This view of the Bure near St Benet's Abbey is taken from near the only other remains of the Abbey complex. At the heighest point there is a large cross inscribed with the word 'peace' and this point gives beautiful panoramic views across this lovely part of Broadland.

Between the two large trees in the middle of the photograph Fleet Dyke provides the access to South Walsham Broad.

OVERLEAF A beautiful twilight sky reflected in the mirror-still waters of South Walsham Broad.

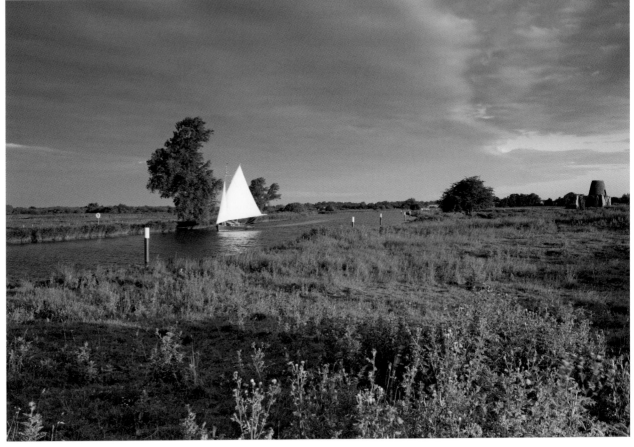

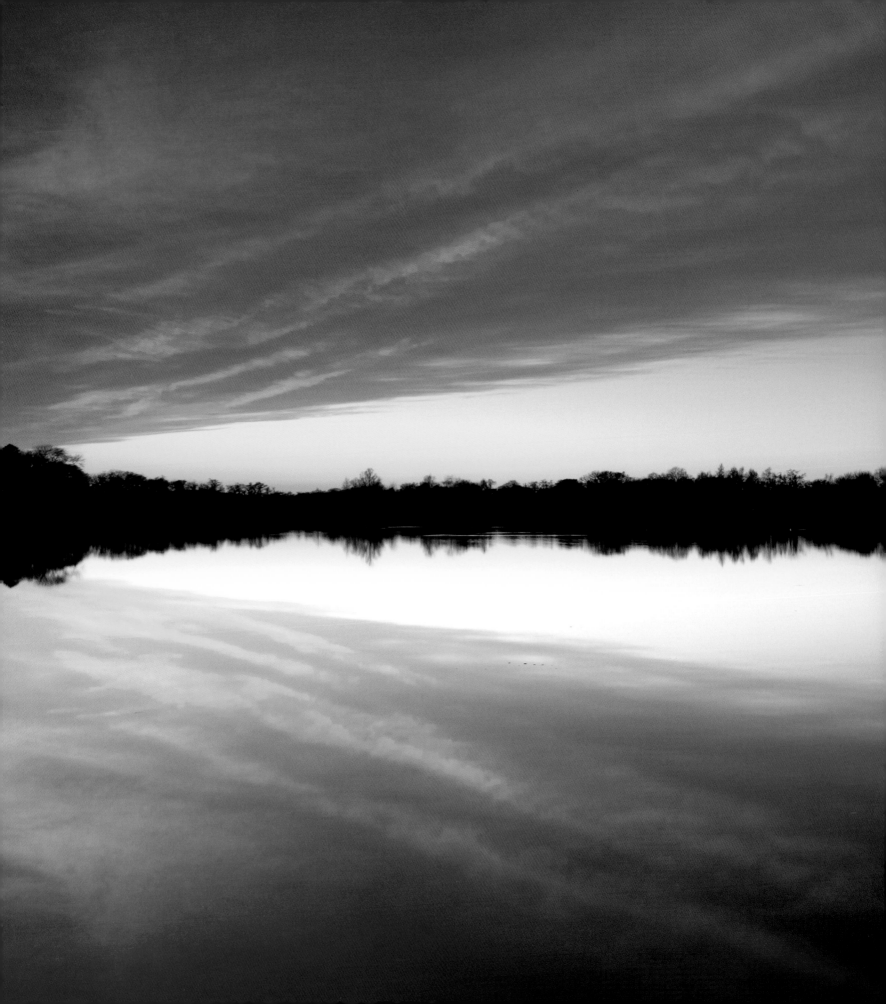

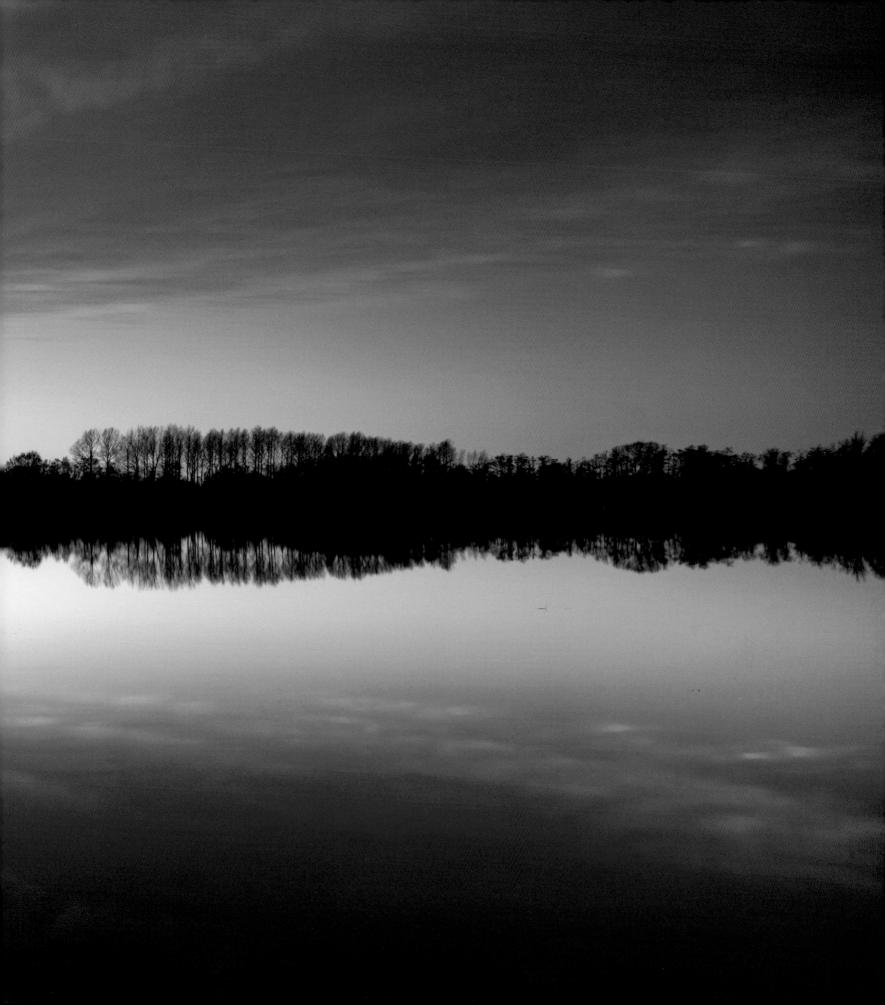

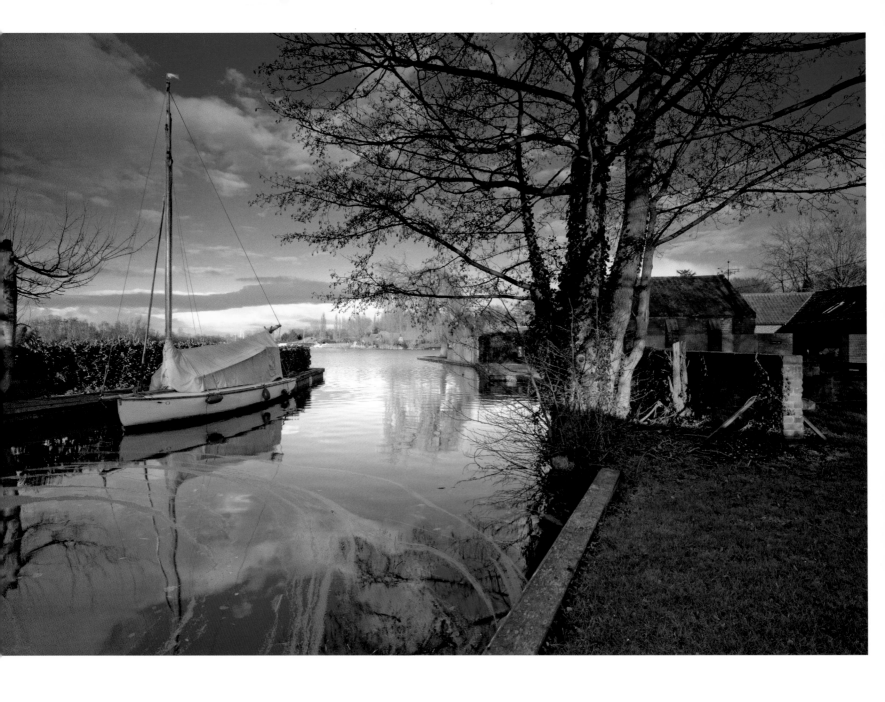

South Walsham Broad is divided into two parts. The Inner
Broad has mooring facilities while the Outer Broad is for
navigation only and is privately owned. This photograph
shows the village staithe at South Walsham Inner Broad.

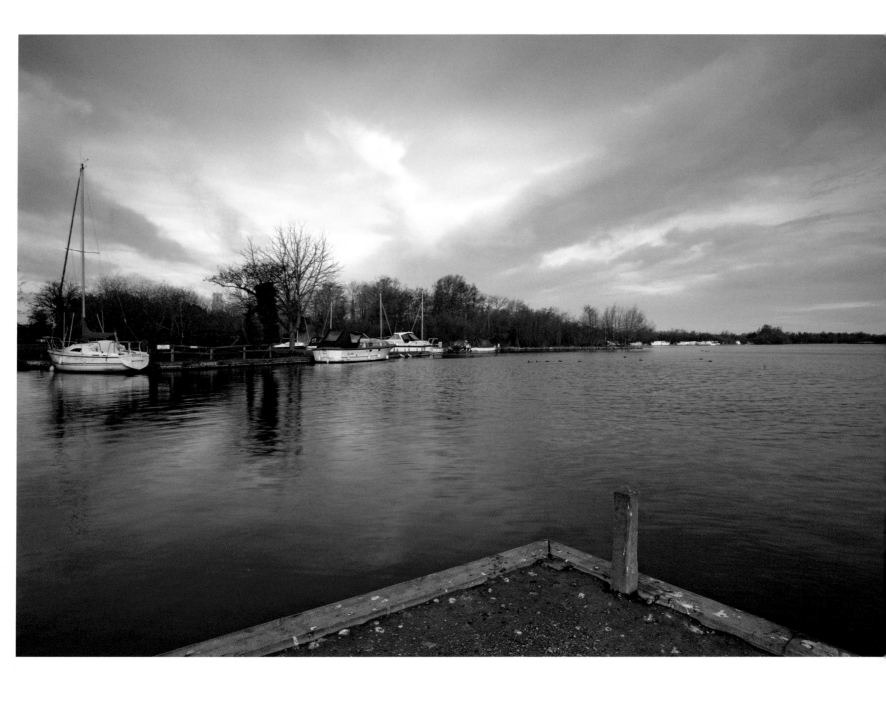

Accessible via Ranworth Dam, Malthouse Broad is a very popular Broad situated in the village of Ranworth. This view shows the tower of St Helen's Church, known as the Cathedral of the Broads, which dates from 1390. The church houses a beautiful painted medieval rood screen and has a vertiginous climb of the tower for beautiful views across the Broadland landscape.

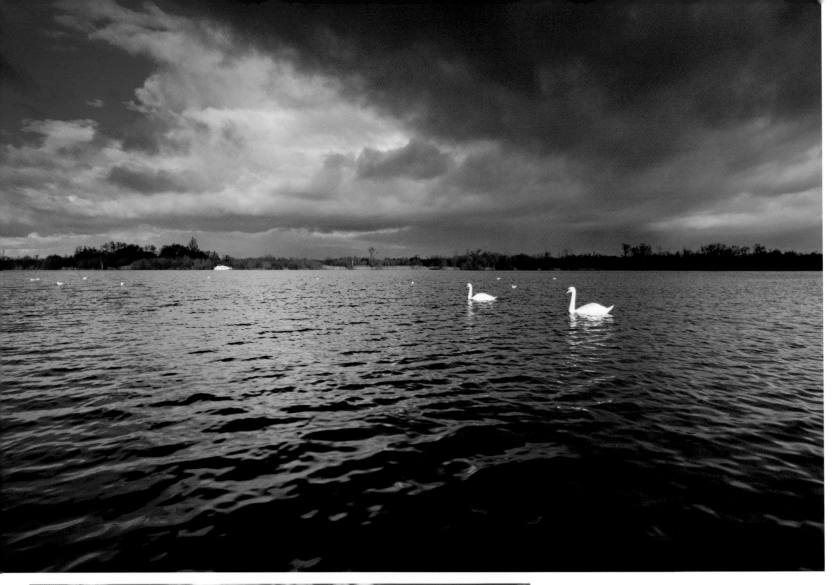

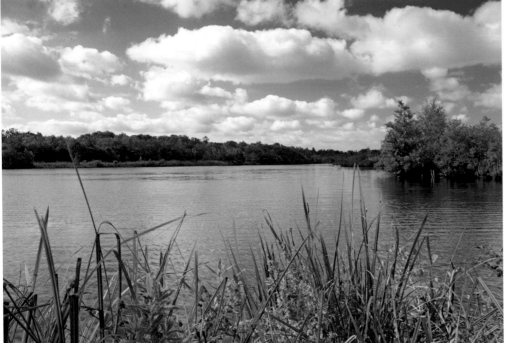

ABOVE A stormy morning at Malthouse Broad.

LEFT Cockshoot Broad on a bright summer's day. Cockshoot Broad and its dyke have been sealed off from the river to improve water quality. This has enabled the broad and dyke to return to an appearance resembling the time before Broads boating holidays increased the traffic along the river causing many environmental problems. Many forms of plants and wildlife have now returned to this area as a result of this action.

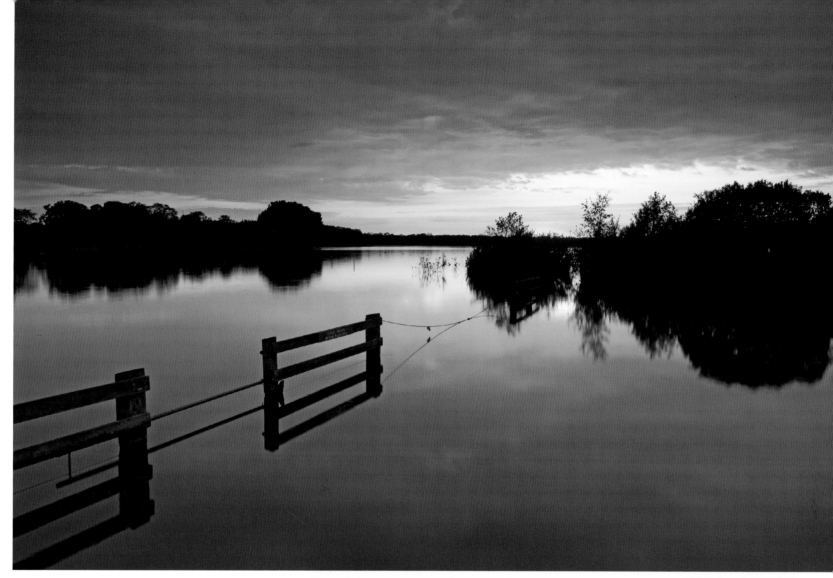

ABOVE Ranworth Broad is adjacent to Malthouse Broad but it is unnavigable and is kept as a nature reserve. From the village of Ranworth there is a boardwalk that leads through woodland and reedbed to a floating educational visitor centre where the wildlife can be observed. This view of a beautiful sunset over the Broad is taken from near the vsitor centre.

RIGHT This view of Hobb's Drainage Mill near Horning is taken from the boardwalk that leads to Cockshoot Dyke and Broad. A walk along this boardwalk, while giving ample opportunity to view the abundant Broadland wildlife, will also enable you to see some of the most exclusive and expensive riverside property in Broadland.

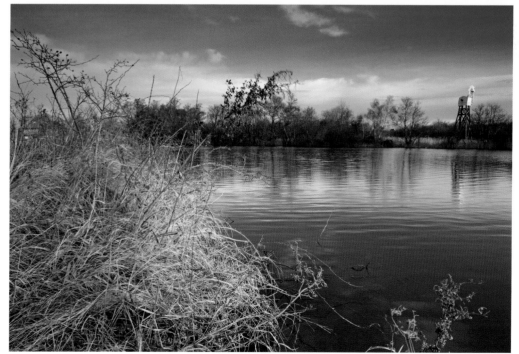

A bright winter morning looking across the river towards the Ferry Inn and the village of Horning. Out of picture to the right is the Horning Marina, which features countless moorings, holiday properties and riverside homes.

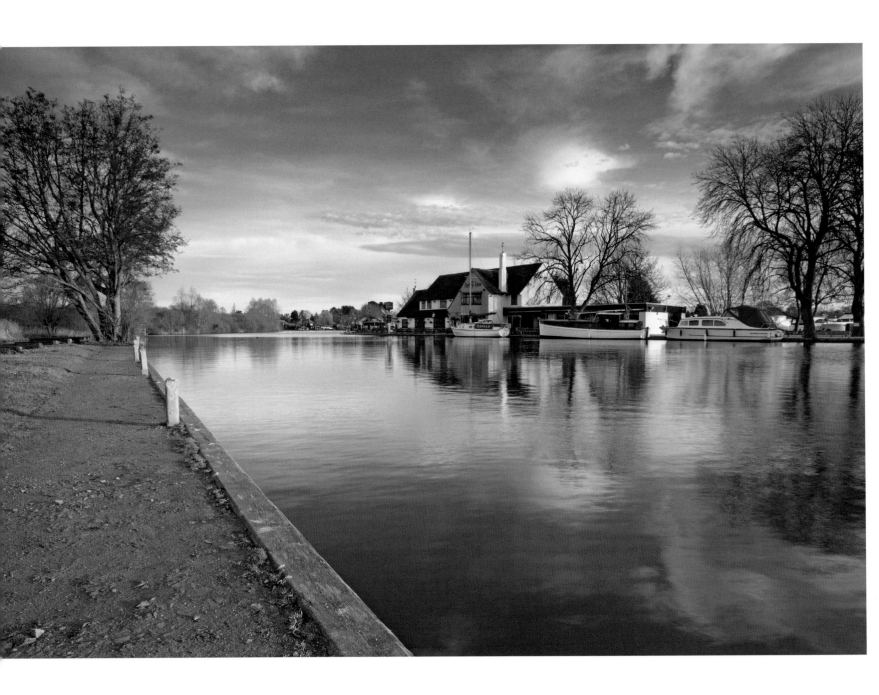

Horning is a beautiful village, justifiably popular in the summer months with holiday visitors frequenting its riverside pubs, restaurants and shops. The view in this winter shot shows Horning Sailing Club and further beautiful riverside properties as the Bure heads towards Hoveton and Salhouse.

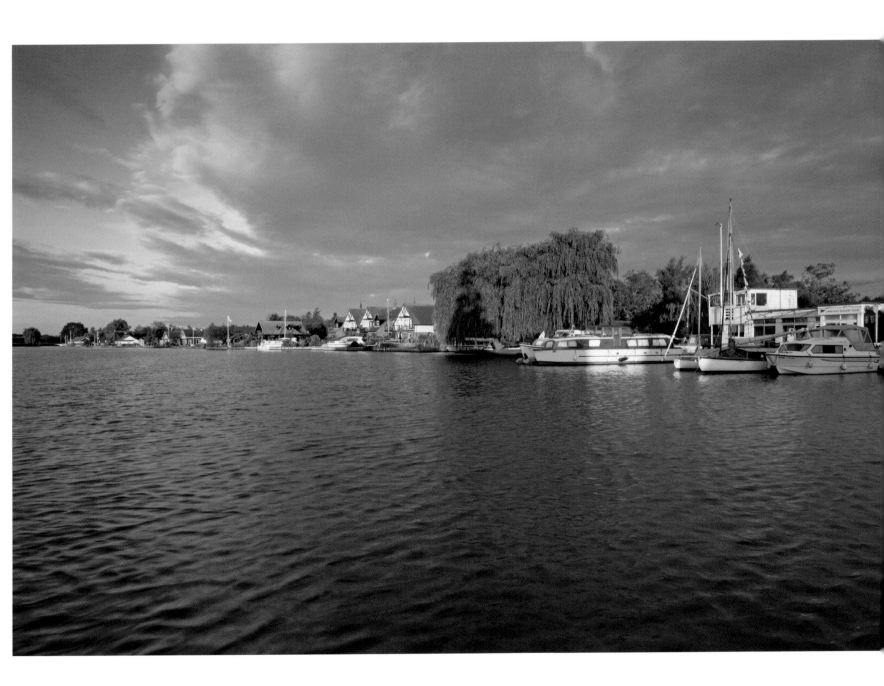

Salhouse Broad must rank as one of my favourite places in the Broads. It is now looked after by its owner and the community of Salhouse. The sloped banks beside the moorings provide a beautiful place to rest a while and take in the beautiful views.

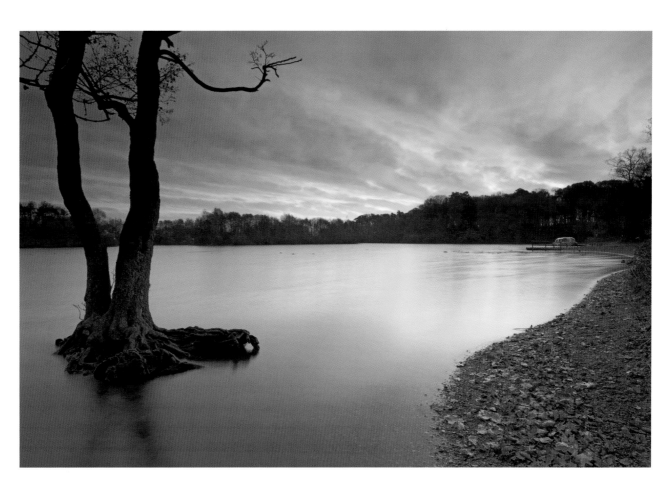

Another view of Salhouse Broad showing this distinctive 'skeletal' tree shape that is a common feature by the banks of the Broads. A lone Broads cruiser sits at the moorings in the distance after an overnight stay.

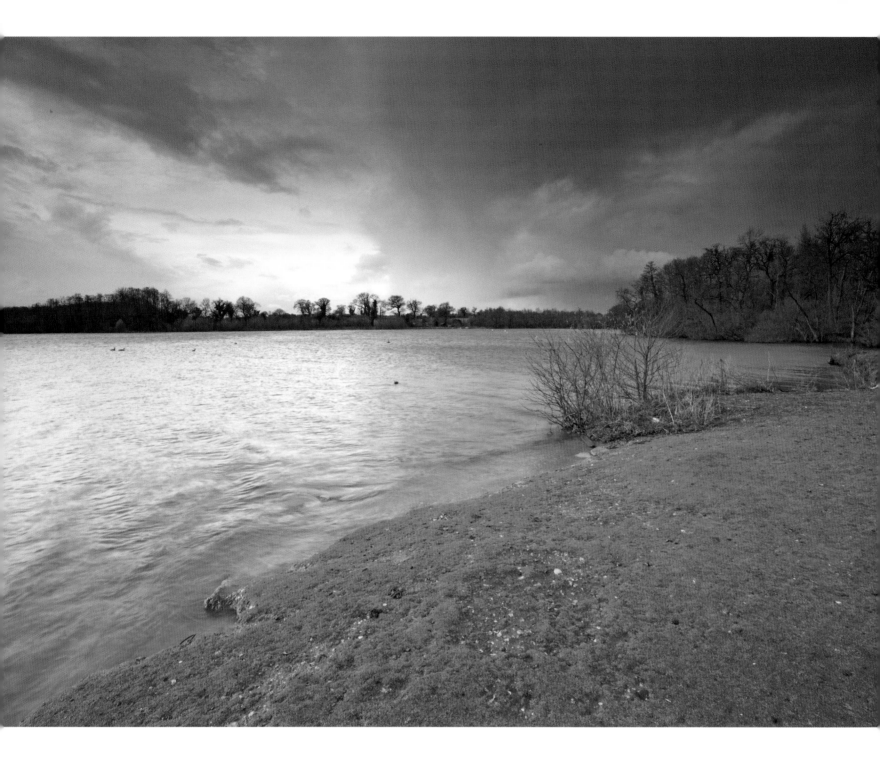

Wroxham Broad taken on a winter morning interspersed with sleet showers, snow showers and periods of sunshine. A photographer's dream weather, in fact! The broad is home to the Norfolk Broads Yacht Club and is a short distance from the village of Wroxham which is one of the main centres in the Broads for both hiring Broads craft for holiday use or taking an arranged short tour of the Broads.

The delightfully small staithe at Belaugh, just beyond Wroxham. There is just about enough space for a couple of boats to moor here but it is a lovely peaceful site to watch the comings and goings of the river.

The village of Coltishall marks the end of the navigable section of the Bure and is a fittingly picturesque village with a large area for moorings and a large green to take in the views.

OVERLEAF A lone fisherman tries his luck beside the river at Coltishall on a bright cloudless morning.

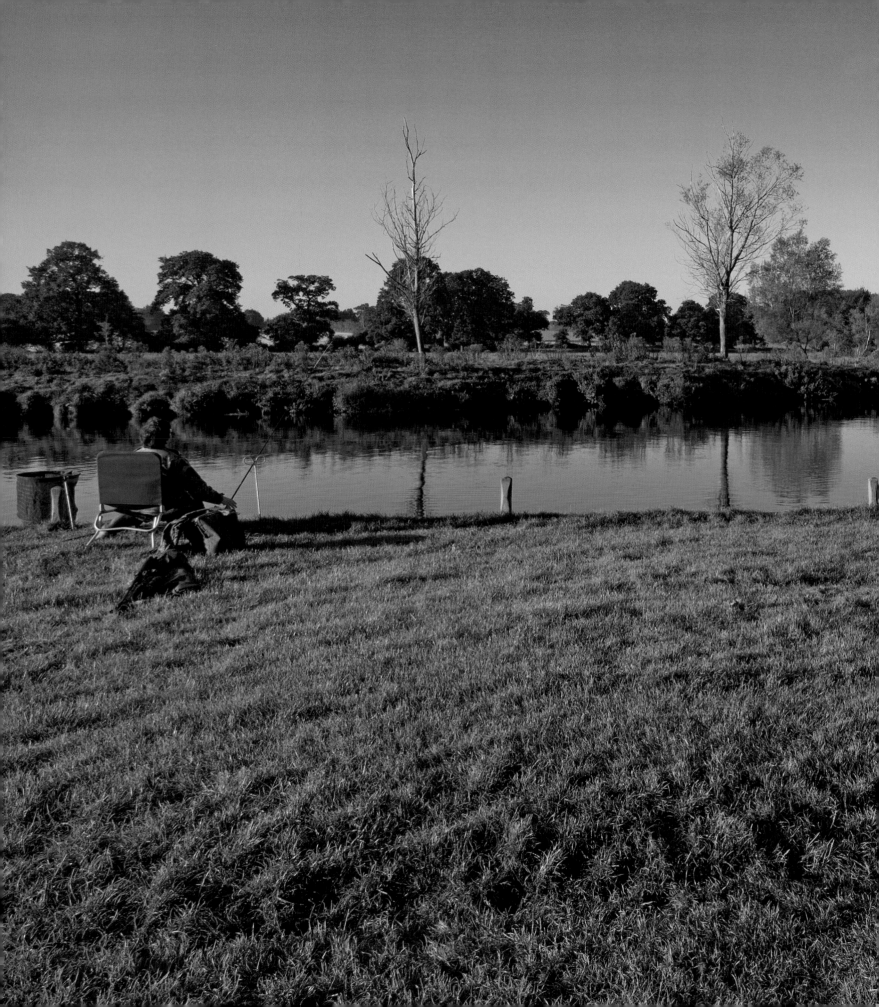

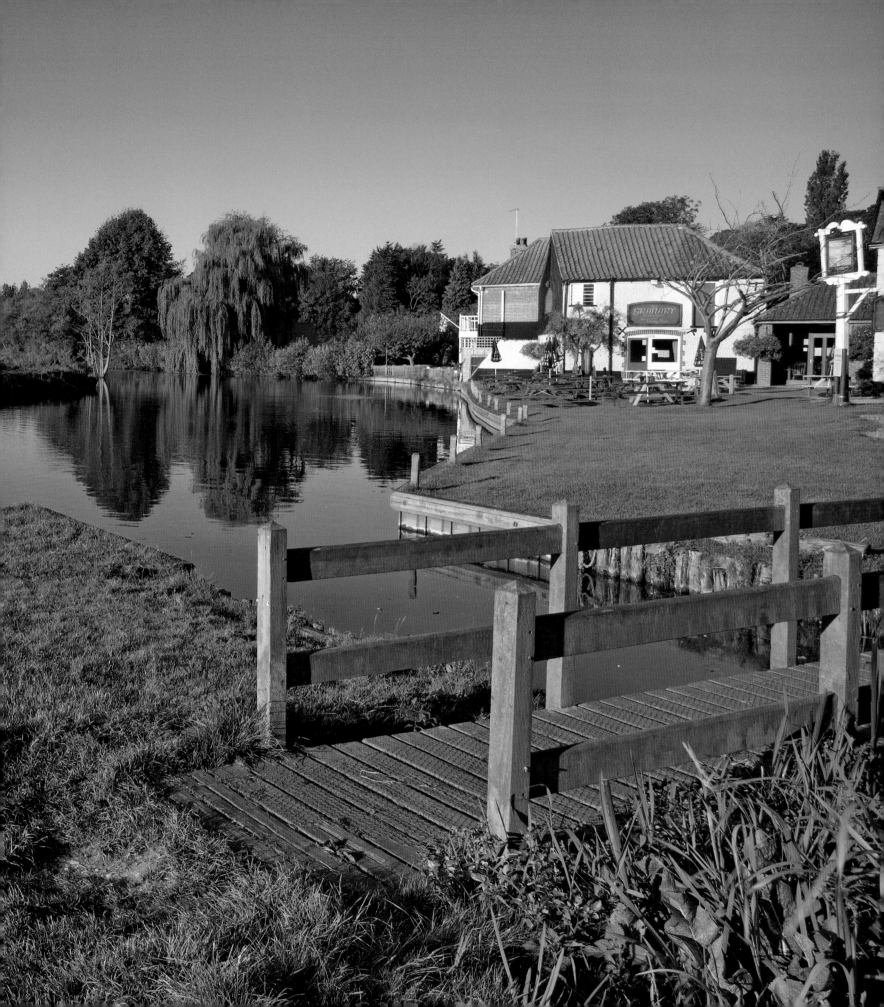

THE RIVER ANT

The River Ant is a tributary of the River Bure, which it joins near St Benet's Abbey after an 8-mile journey from its limit of navigation at Wayford Bridge near the village of Smallburgh.

The first moorings along the River are at Ludham Bridge. This view shows Ludham Bridge Boatyard on a frosty morning.

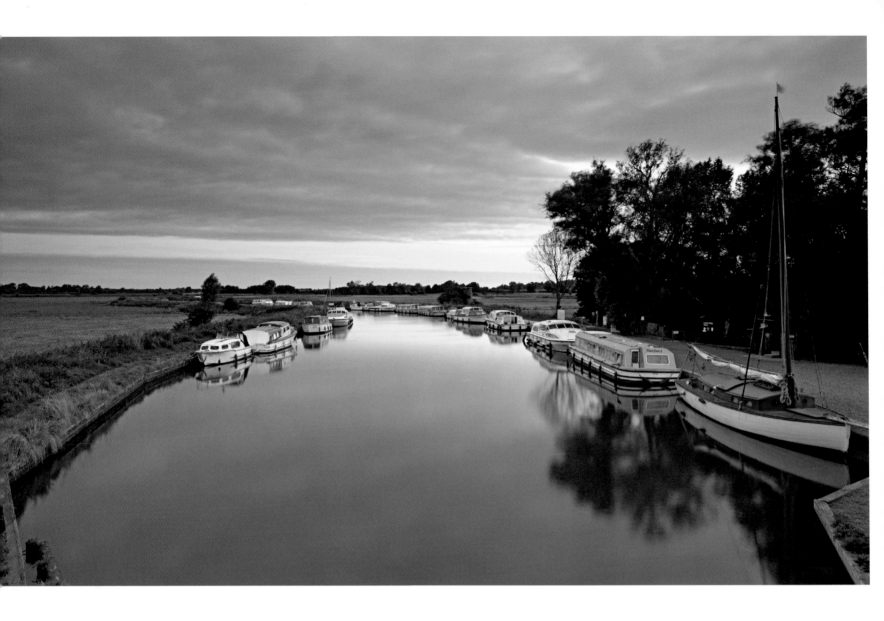

The view from Ludham Bridge showing the staithe, with both traditional and modern Broads craft moored up. The bridge itself has very limited clearance, so those hoping to navigate this part of the Broads need to know both their craft's height and the correct time to pass under the bridge due to the tides.

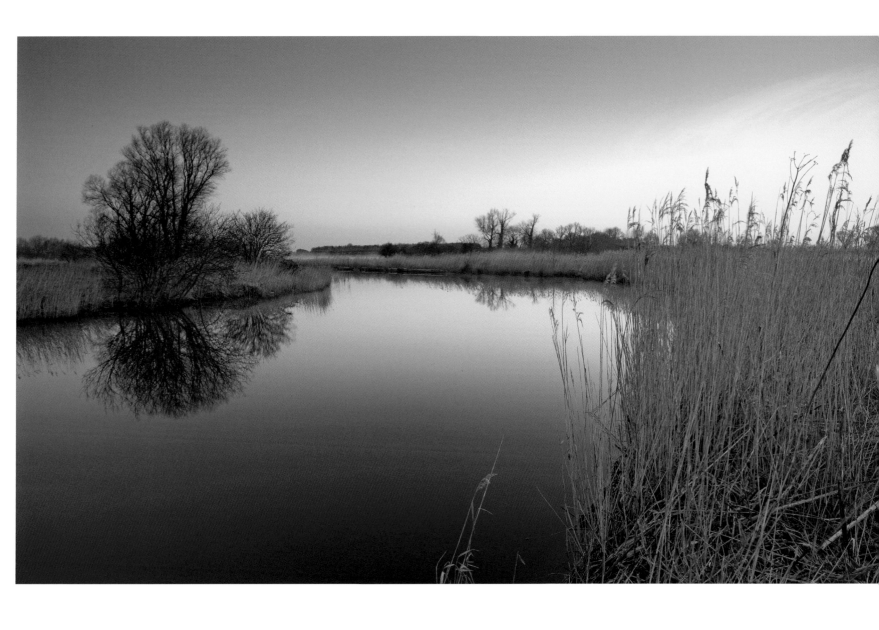

A favourite walk of mine in the Broads is between Ludham Bridge and How Hill. On a still morning the pre-dawn light creates a peaceful scene by the banks of the river near Ludham Bridge.

The sun rises on a misty morning by the banks of the river showing Neaves Drainage Mill.

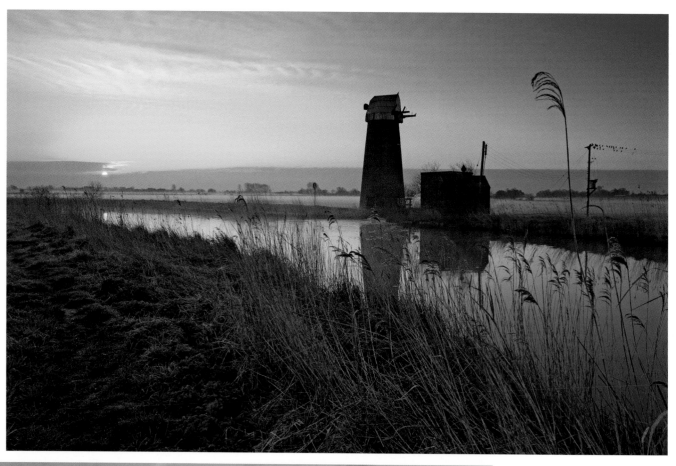

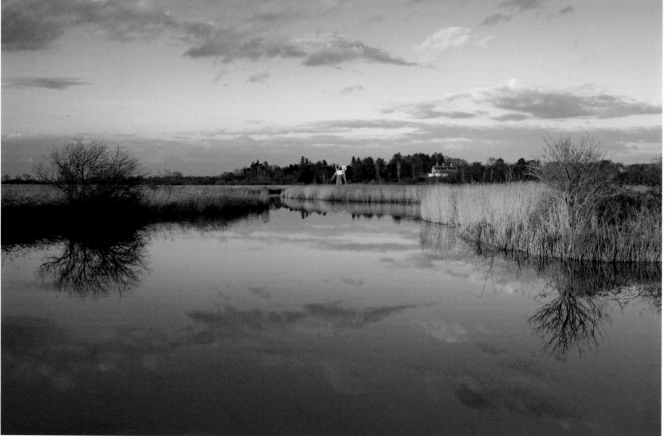

Beautiful light enhances the golden colours of the reeds in this riverside view looking towards Turf Fen Mill and How Hill House.

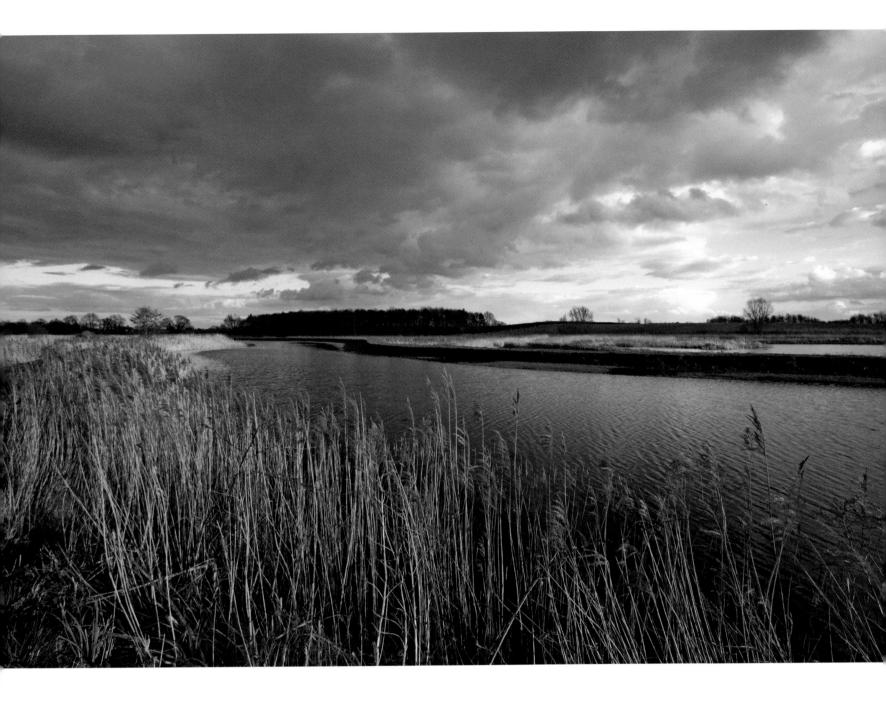

A moody sky is the backdrop to this view of the landscape near How Hill. The work to preserve the fragile environment of the Broads is ongoing and this view shows a drainage channel dug out to reduce the risk of widespread flooding.

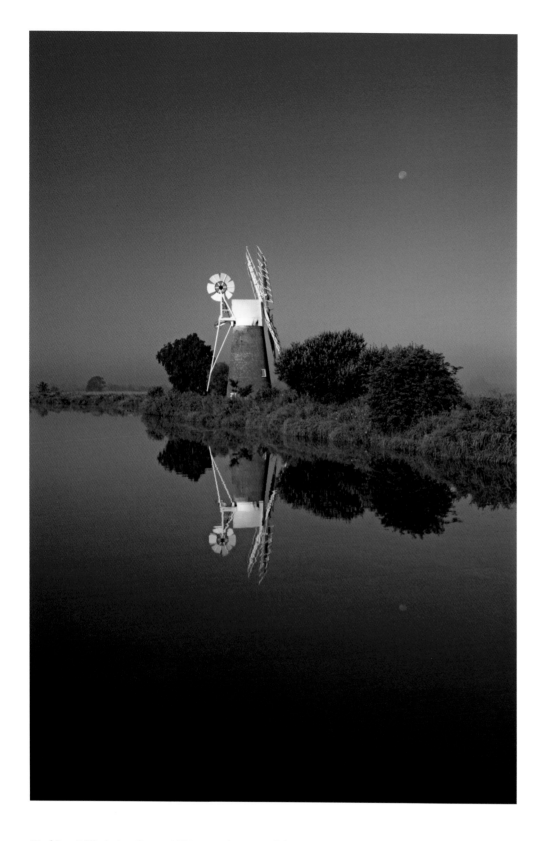

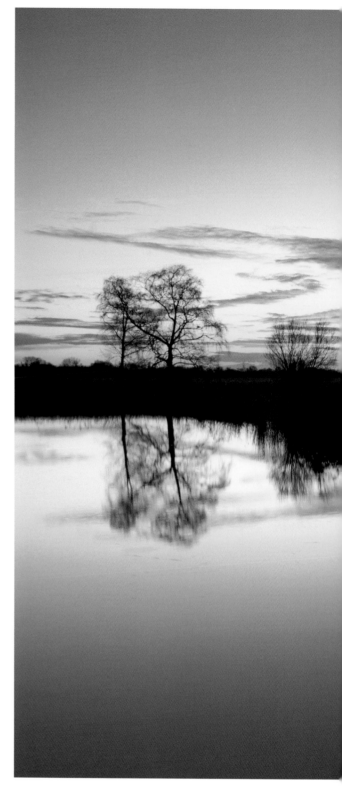

Turf Fen Mill, dating from c.1875, must be one of the most photographed mills on the Broads. Until his recent retirement, Eric Edwards MBE was a regular sight on the marshes near to the mill as the Broads Authority's Marshman for this site cutting reed and sedge in the traditional style.

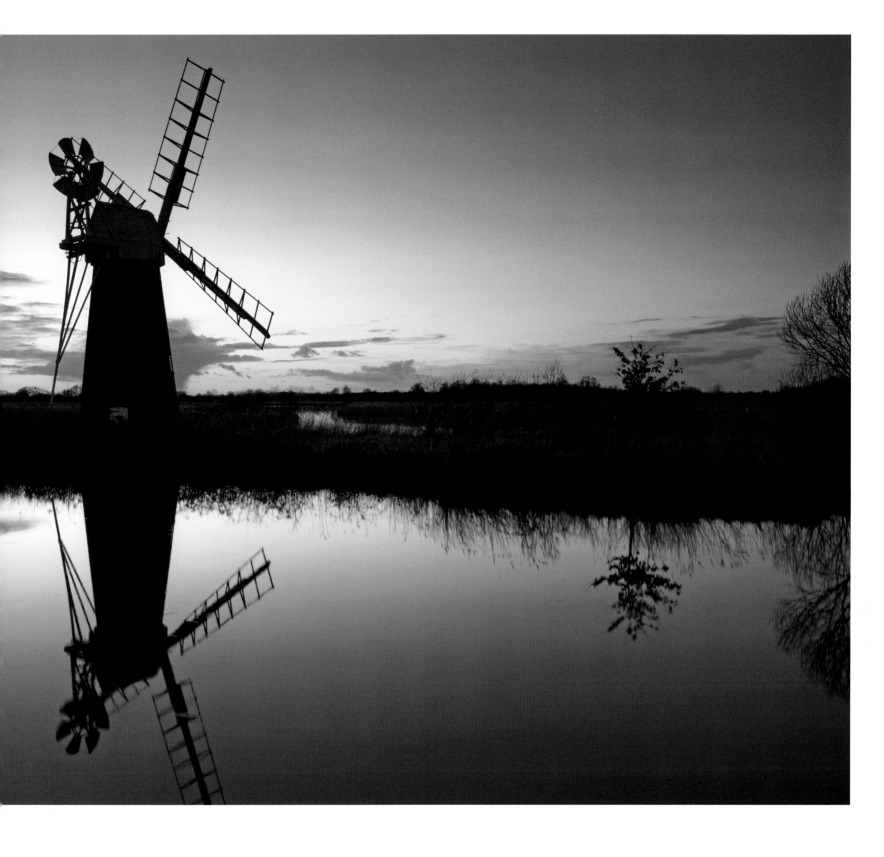

A view of Turf Fen Mill silhouetted against a beautiful sunset.

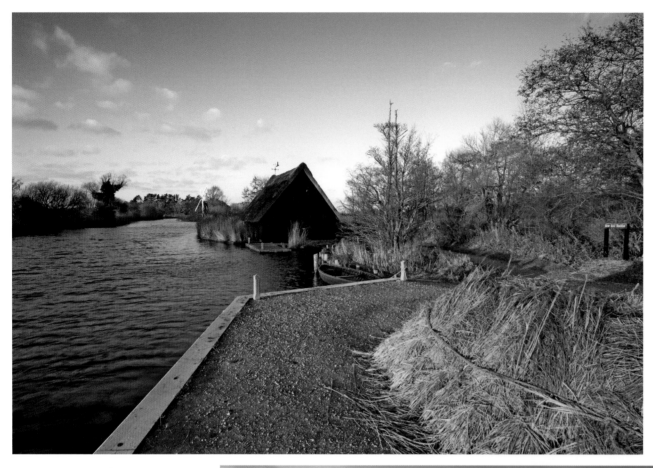

How Hill Staithe is a beautiful part of the Broads, which has become a regular place for myself and my family to visit. There are nature trails, electric boat trips to view the river's wildlife, a traditional marshman's home to visit called Toad Hole Cottage and a beautiful expanse of grass overlooking the river to sit and have a picnic on. It is also home to the How Hill Trust's Education Centre based at How Hill House, which provides courses and the opportunity to study the Broadland environment for both adults and children.

I was photographing at Ludham Bridge when I caught the beautiful site of a distinctive wherry sail on the horizon. As it neared I could see it was *White Moth*, a wherry yacht that can be chartered. I had a quick chat with the people on board and said I would catch them at How Hill for a picture. They were obviously having a great trip out, helped by the many bottles of wine visible on a table at the back of the wherry. I got to How Hill and waited patiently by the staithe for this beautiful craft to pass by, while having glasses raised to me by the 'happy' crew.

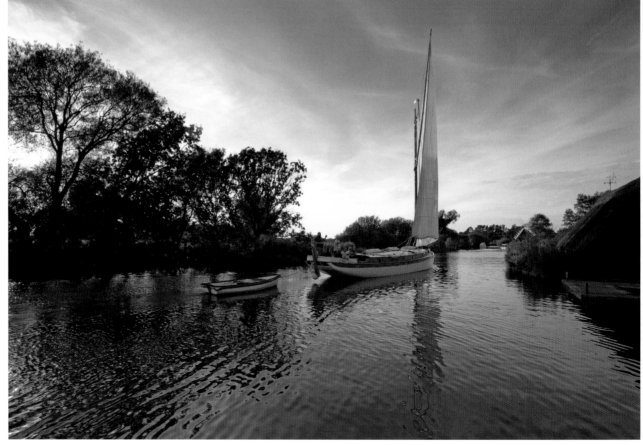

A short walk along the river from How Hill Staithe brings you to two distinct drainage mills that sit beside the river. The mill in this image is Clayrack's Mill, which, like Palmer's Mill at Upton, is a hollow post mill. The mill was moved to this spot in 1981 from Ranworth Marshes.

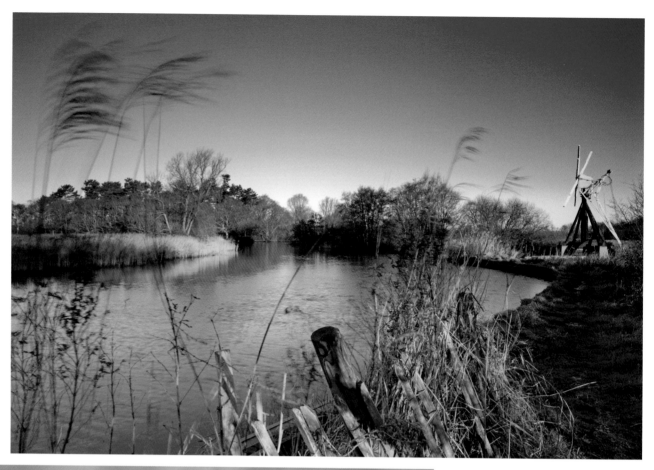

Barton Broad is the second largest of the Broads after Hickling Broad. Its once crystal-clear waters were darkened by algae, which blocks out sunlight and means that submerged plants die and form a muddy deposit on the Broads bottom as they rot.

The Clear Water 2000 project dredged a huge amount of this silty deposit from the Broad. Fish-proof curtains, one of which is visble in the picture, were set up around the Broad to encourage the growth of *Daphnia*, a tiny water-flea that eats away at the algae thus restoring the condition of the Broads water. This project has been a great success and there has been an abundance of wildlife returning to the Broad.

Gay's Staithe is situated on Limekiln Dyke which leads off
from Barton Broad. In this view cold overnight conditions
have led to a partially frozen water surface. One of the more
unusual boats on the Broads, *Ra*, named after the Egyptian
sun god, is a solar-powered craft that takes visitors on trips
around Barton Broad from Gay's Staithe.

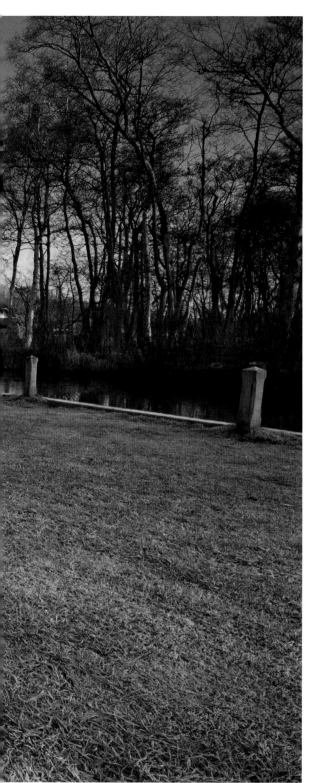

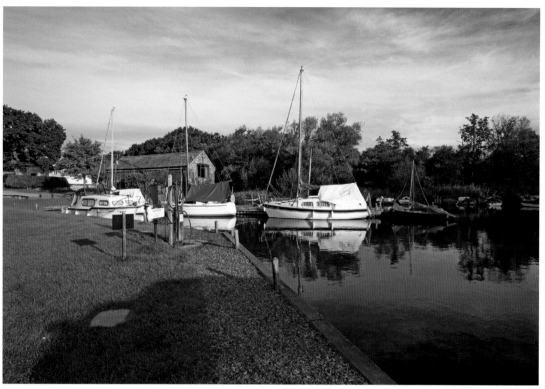

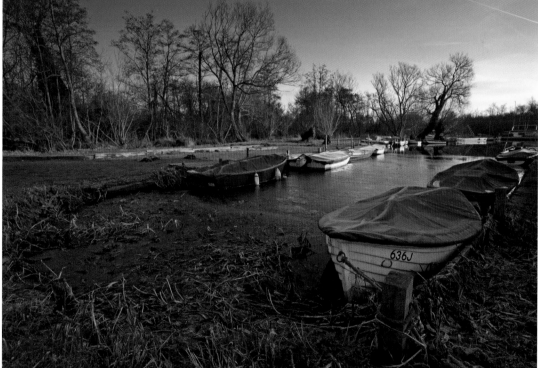

TOP Barton Turf is a quiet village situated next to Barton Broad with many moorings and boatyards.

ABOVE Early morning light illuminates the moorings at Barton Turf.

Alderfen Broad is a nature reserve which can be reached from the village of Neatishead. It is an area of open water, alder carr woodland and fen. In this picture the bright light of a winter afternoon illuminates the alders that surround this relatively unknown part of Broadland.

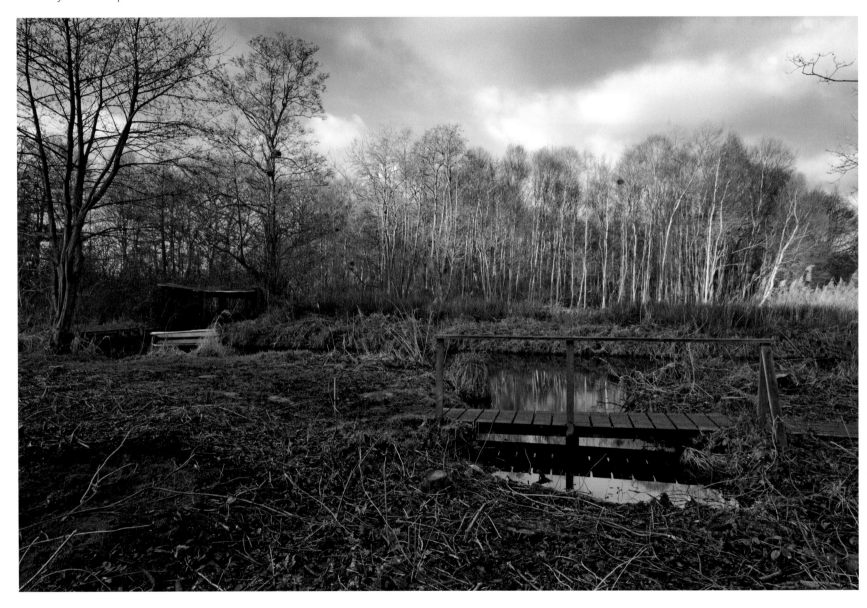

Though a clear sky may not always be the best choice photographically, the golden hues of the reeds against a clear blue sky are wonderfully complimentary as in this view of Alderfen Broad.

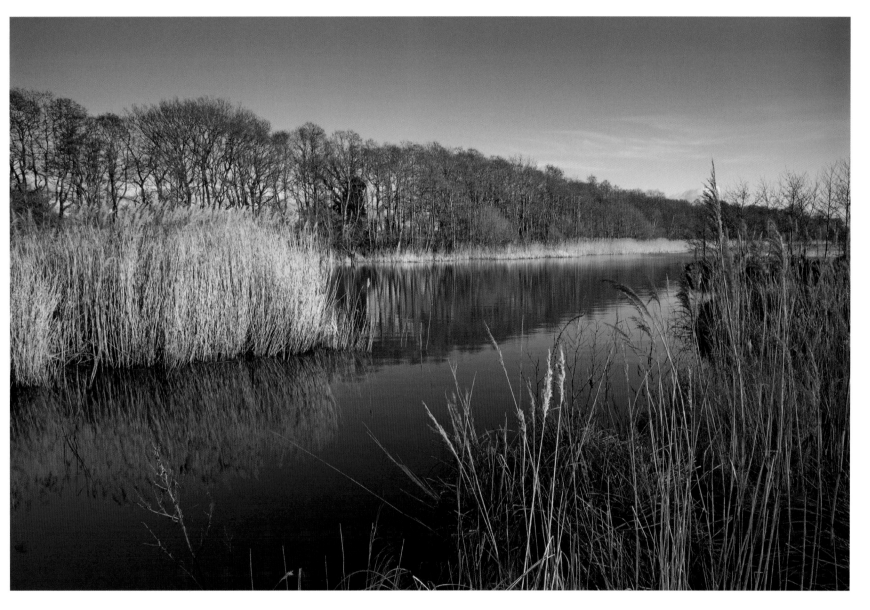

OVERLEAF The limit of navigation for the river can be found at Wayford Bridge near the village of Smallburgh. A couple of hundred yards beyond the bridge the river meets the North Walsham and Dilham Canal at Smallburgh.

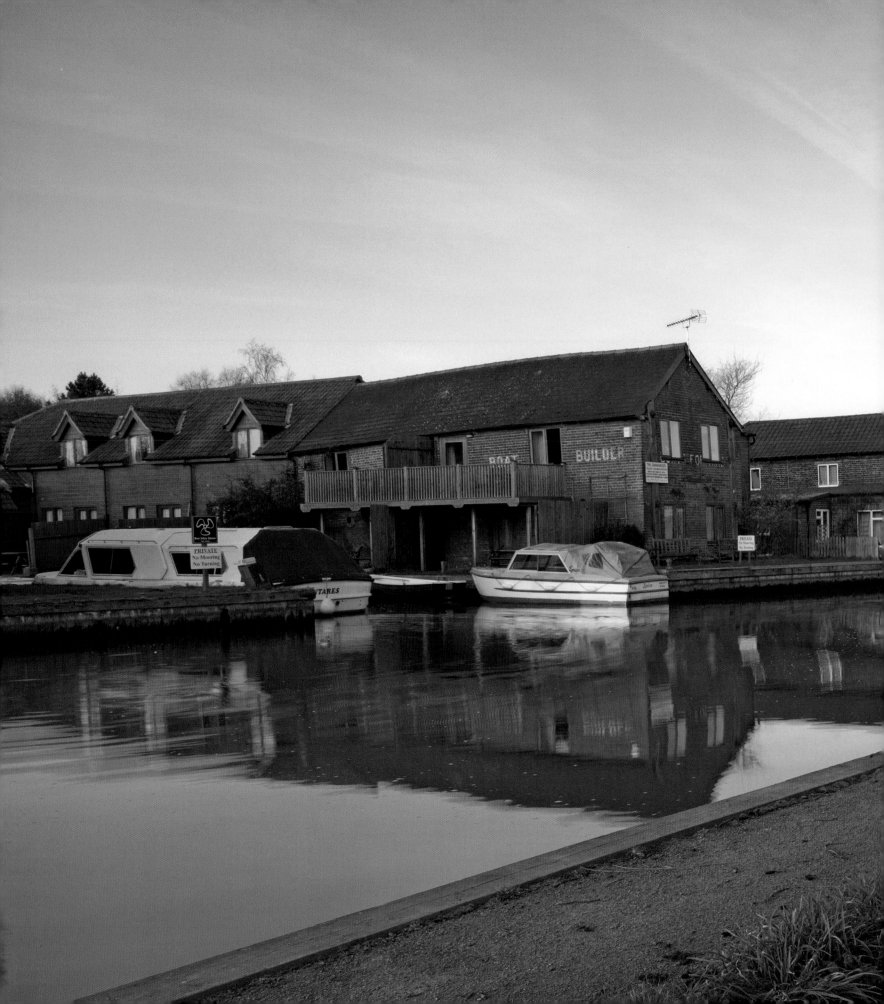

THE RIVER THURNE

The River Thurne is a tributary of the River Bure.

Its journey begins at Martham Broad and ends at

Thurne Mouth, a distance of 5¾ miles.

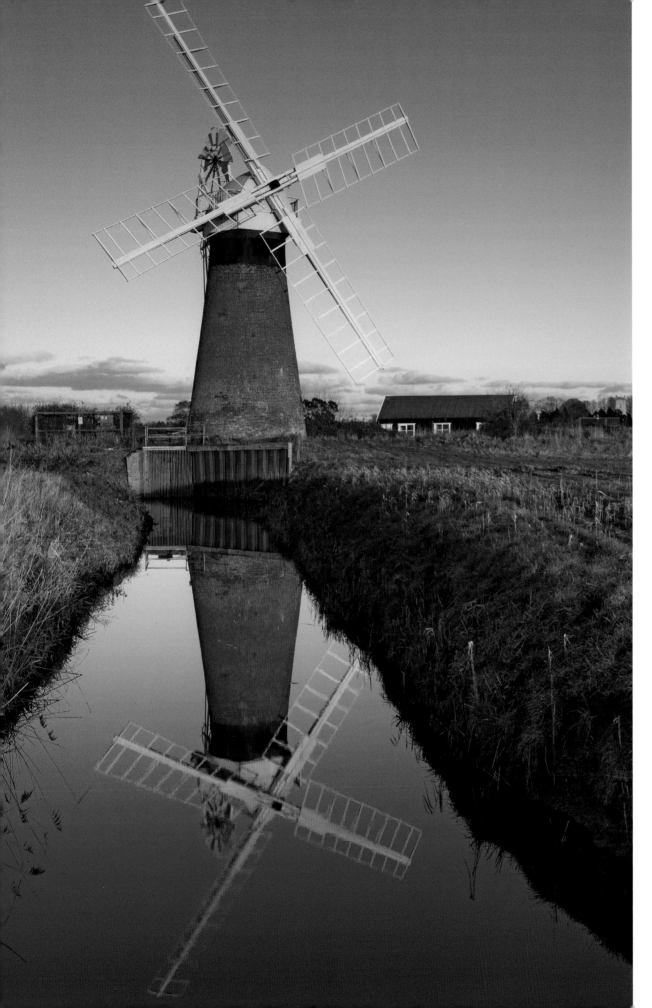

St Benet's Level Drainage Mill is a short distance from Thurne Mouth on the west bank of the river. A calm and clear winter's day sees this beautiful mill reflected in a drainage dyke.

In the far distance the light also catches the fourteenth century church of St Edmund at Thurne, which is built on a hill giving it a fine panoramic view of the Bure valley and Thurne Mouth.

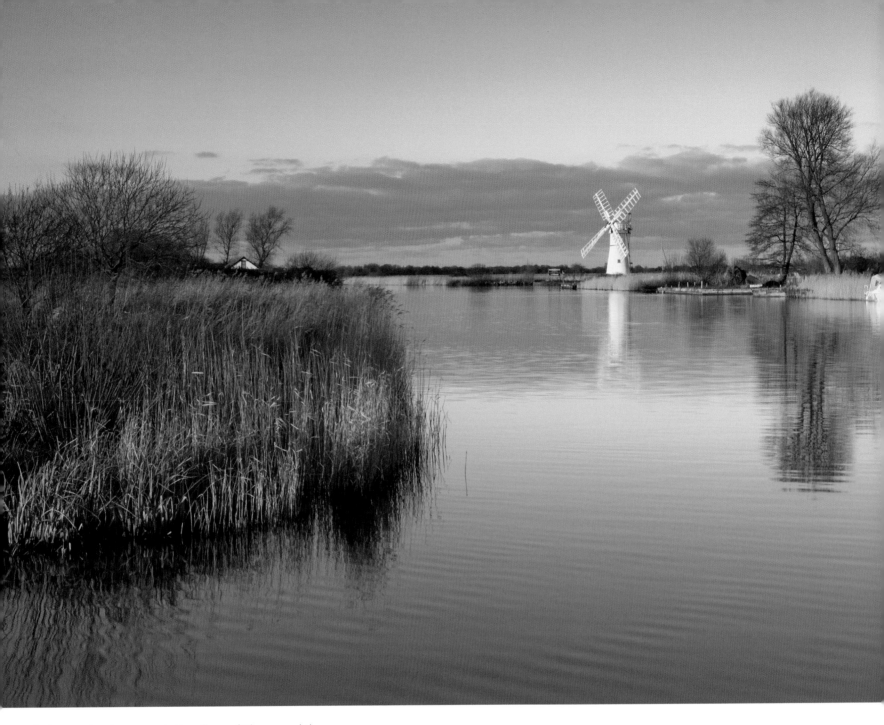

A view up the river towards the village of Thurne and the famous white drainage mill at the entrance to Thurne Staithe.

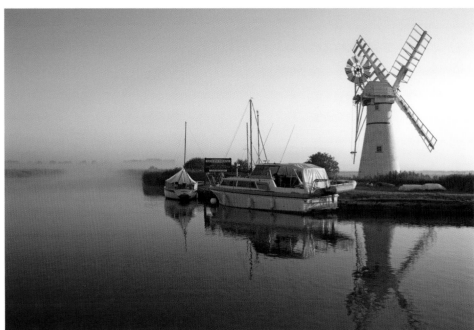

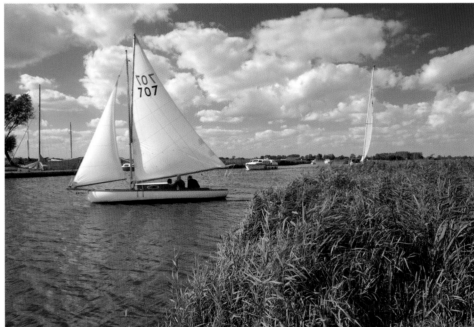

TOP An early morning mist hangs over the surface of the river as the first light of day hits Thurne Drainage Mill. The mill itself can be said to be an iconic symbol of the Broads and is very popular with fellow photographers. It is in the care of the Norfolk Windmills Trust, who have saved many examples in the region from falling into a state of disrepair.

ABOVE A busy summer's afternoon sees many different forms of Broads craft out on the river enjoying the fine weather at Thurne.

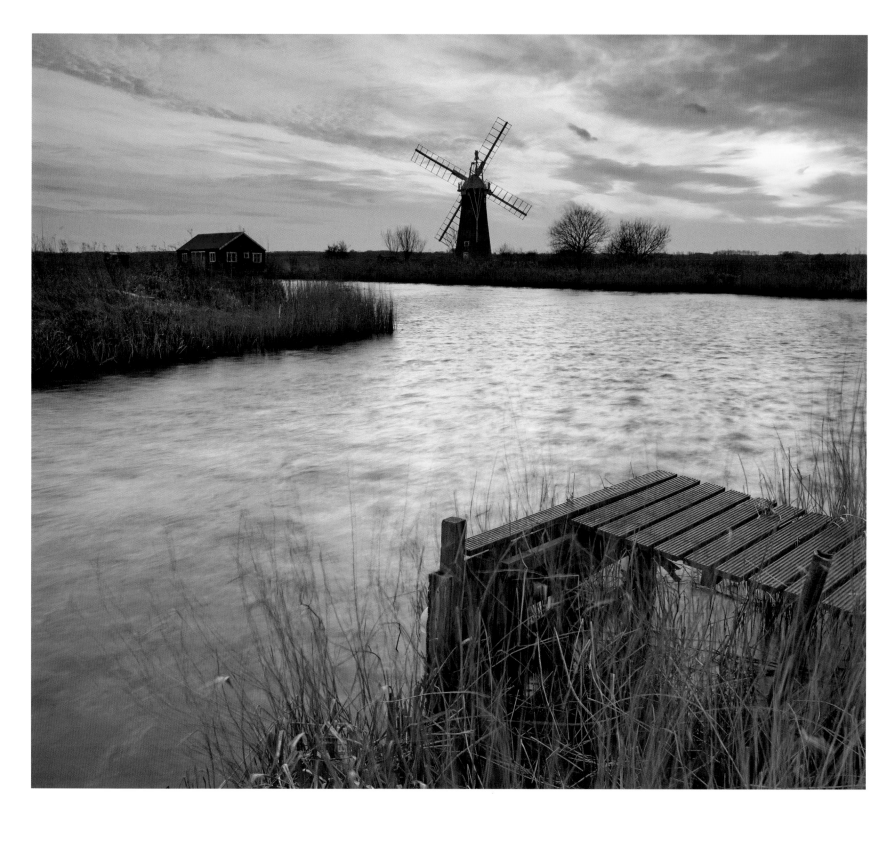

St Benet's Level Drainage Mill is viewed from the Thurne side
of the river against a beautiful sunset.

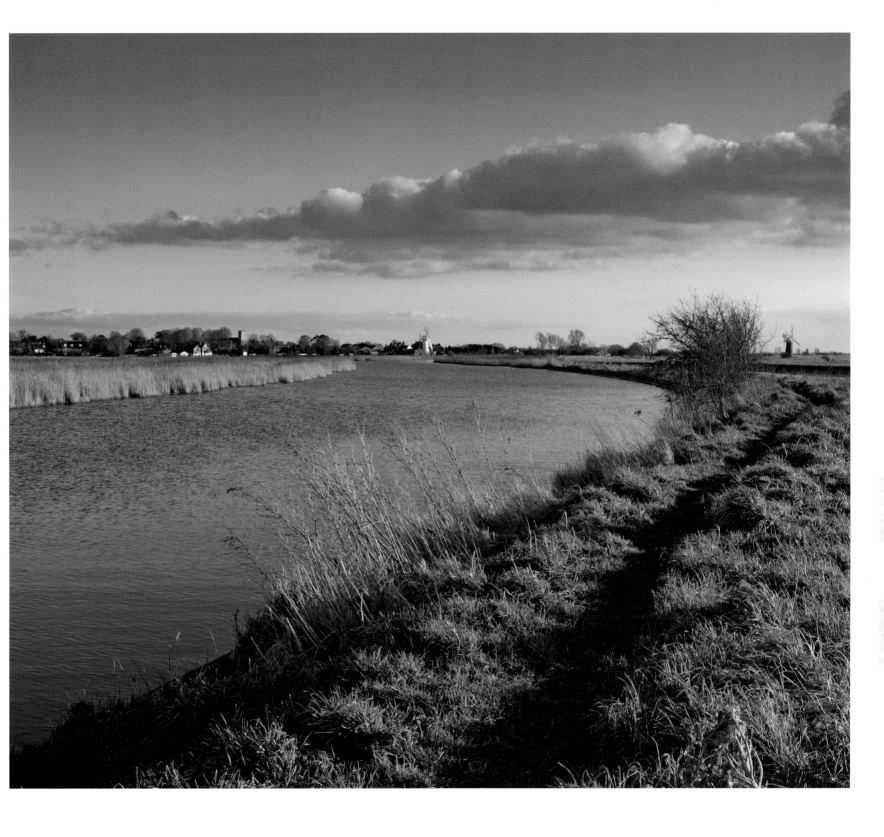

Thurne village as seen from the banks of the river near the entrance to Womack Water.

Womack Water is a dyke that branches off from the river just north of Thurne and leads to Womack Staithe in the picturesque village of Ludham.

Approximately half way down the dyke is Hunter's Yard, which features in this image caught in beautiful light in the middle of summer. Hunter's Yard has been in operation for over seventy-five years. It has a beautiful fleet of Vroads craft that can be hired to experience the Broads in a more traditional way.

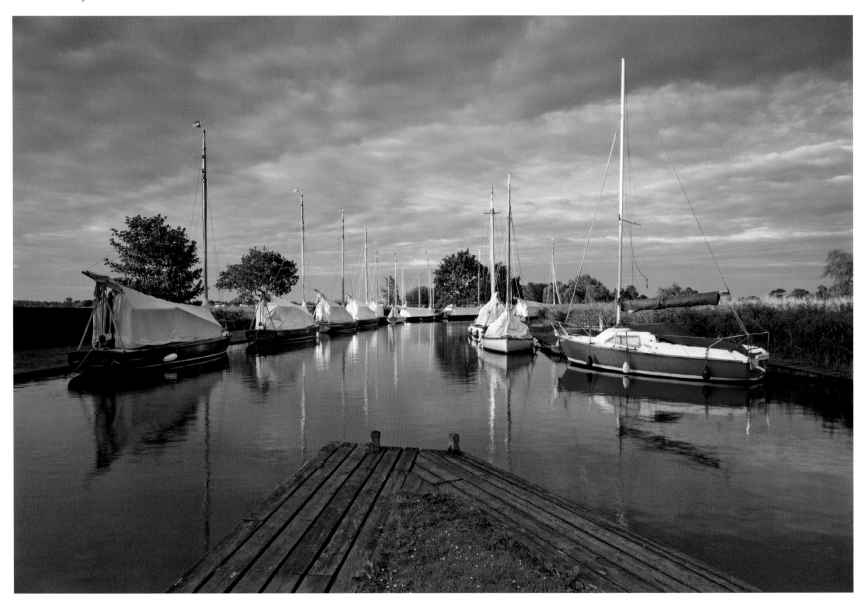

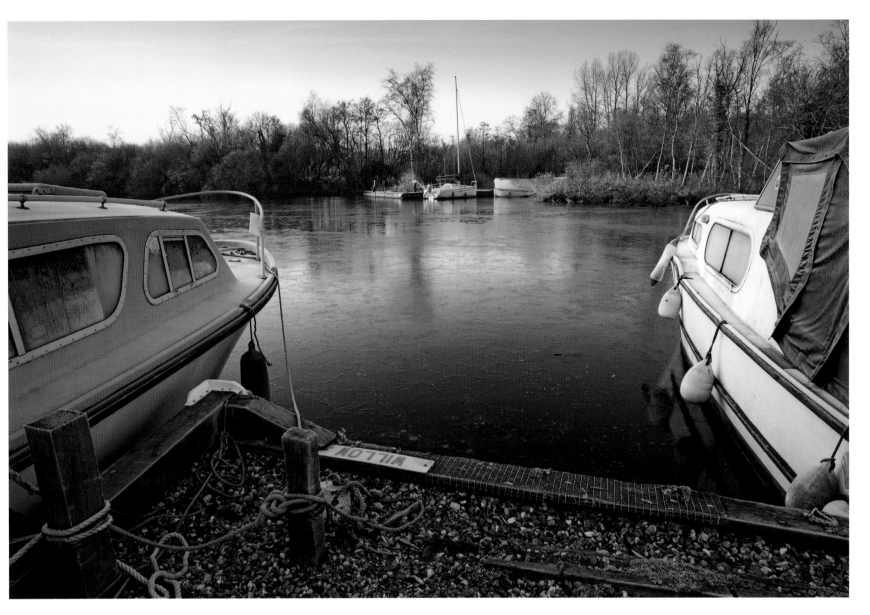

First light at a frosty Womack Staithe. This is a popular summer mooring for visiting the village of Ludham with its beautiful church of St Catherine.

OVERLEAF Three miles up the river from Thurne is Potter Heigham, which is a hub of activity in the height of the summer season as a base for hiring craft and taking trips on the Broads.

In this early morning view the notoriously difficult to navigate Potter Heigham Bridge can be seen. This ancient bridge requires a bridge pilot to navigate craft through to continue their journey along the river.

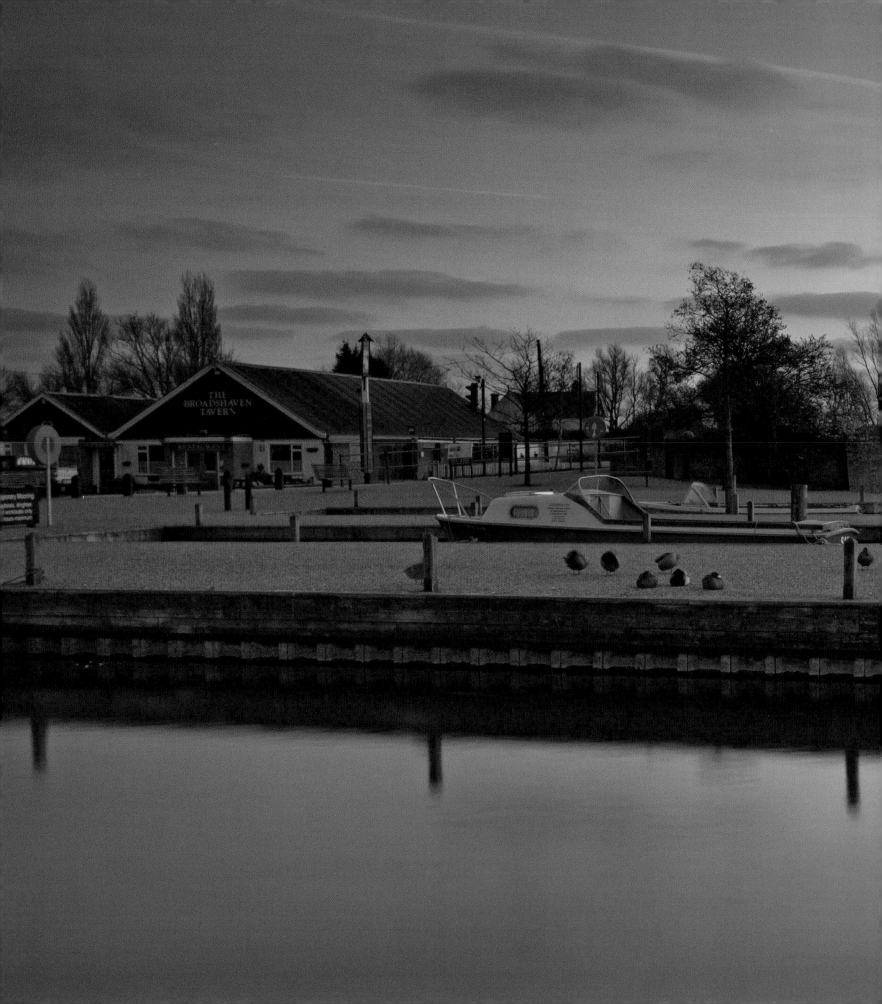

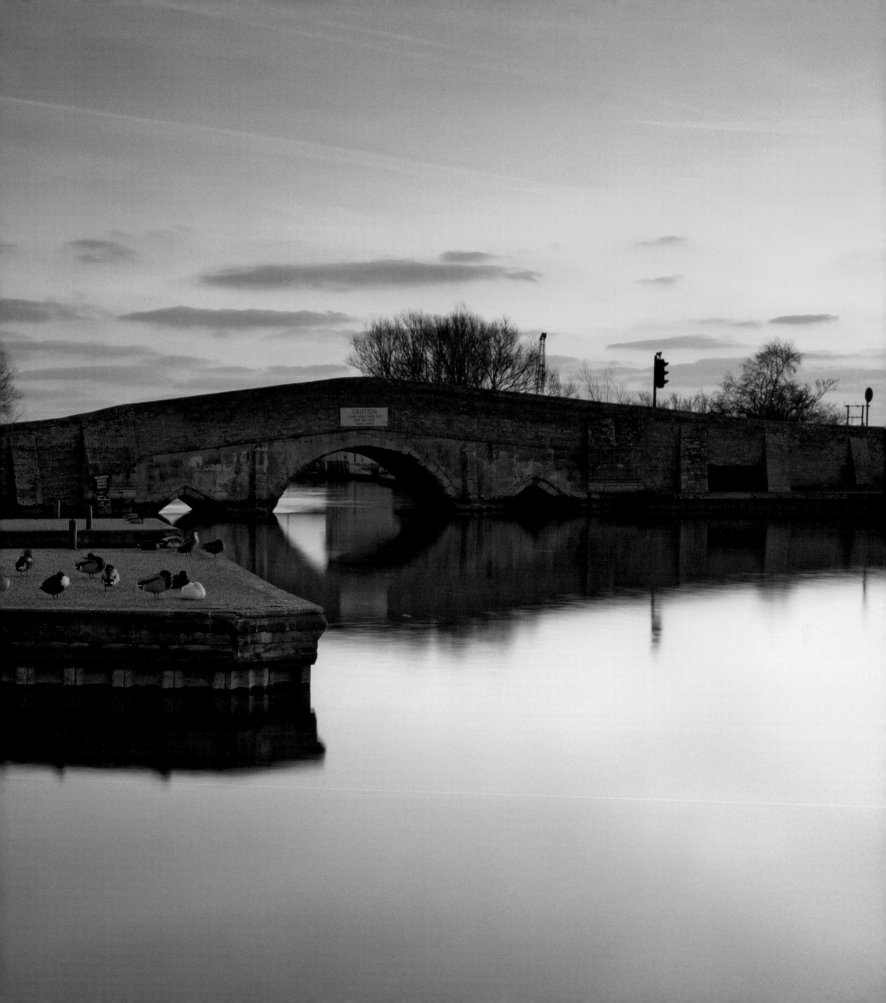

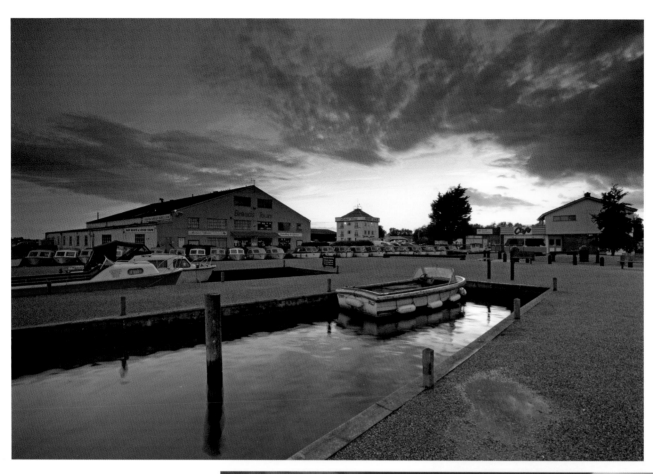

A stunning sunset at Potter Heigham showing a line of day boats that can be hired for a short trip on the Broads. The 'tower' in the distance is part of the Herbert Woods Boatyard, which was established at Potter Heigham in 1928.

A general view of Potter Heigham taken from the bridge that spans the entrance to the Herbert Woods Boatyard, which can be seen on the left.

Early light on the river showing a beautiful riverside property of which there are numerous examples on both banks of the river at Potter Heigham.

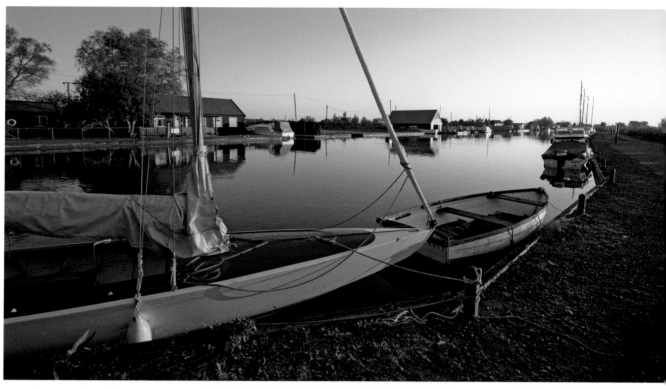

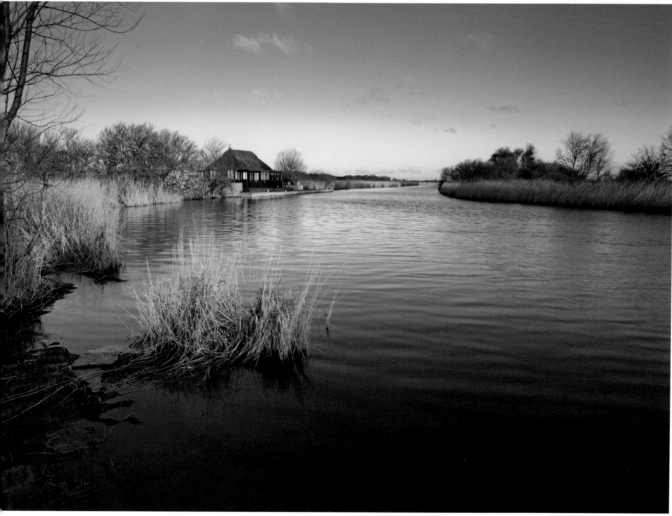

Candle Dyke can be found a mile and a half up river from Potter Heigham. It is the access dyke to Hickling Broad, the largest of all the broads, which can be reached after passing through Heigham Sound in the far distance of the picture.

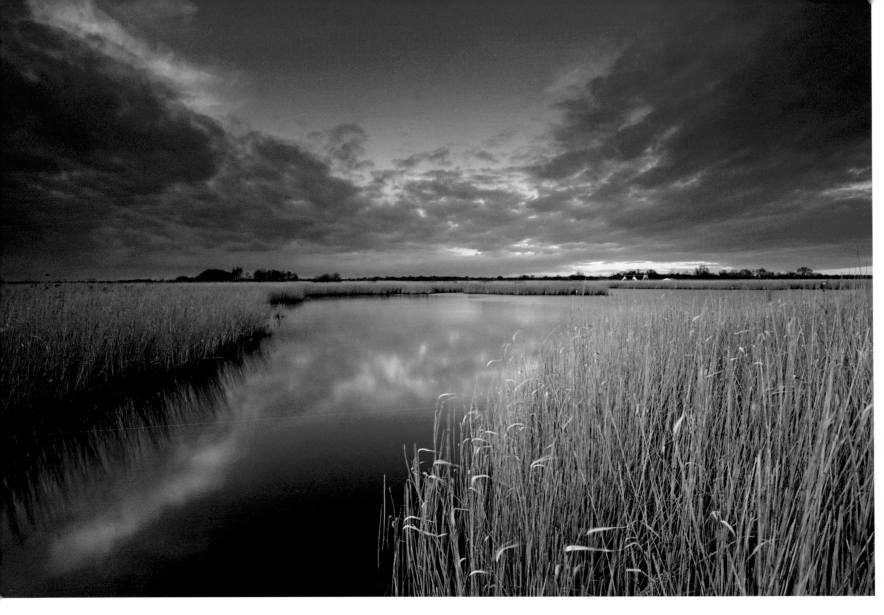

The calm water of a small inlet near Hickling Broad reflects
a dramatic sky at twilight.

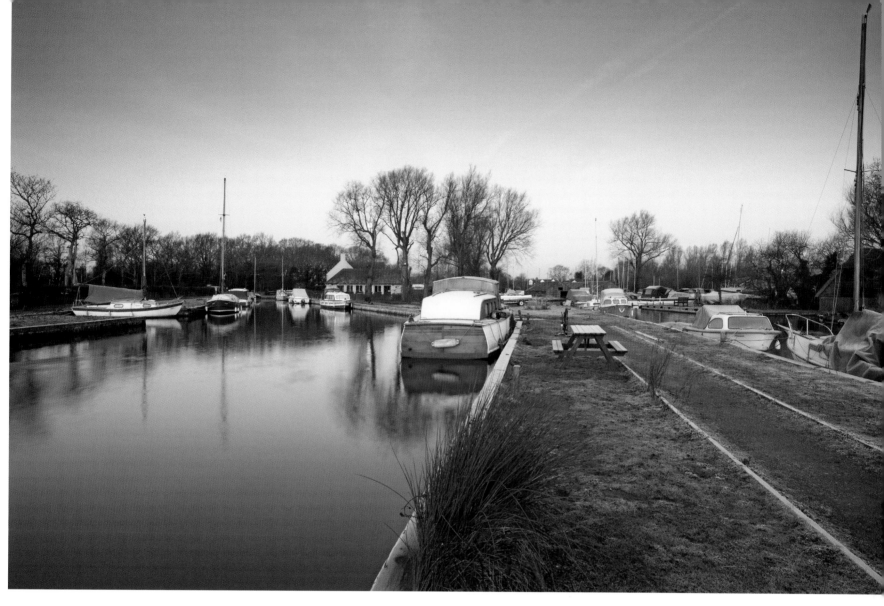

A frosty morning at Hickling Staithe, with The Pleasure Boat
Inn in the distance.

OVERLEAF Sunrise at Hickling, the largest of the Broads, from
Hickling Staithe, showing the boathouses and three perfectly
positioned yachts whose positioning this landscape
photographer was extremely grateful for.

The Broad is a National Nature Reserve, with many walks
along its banks, and is a haven for wildlife enthusiasts.
Unfortunately for the photographer there are not too many
open views of the Broad.

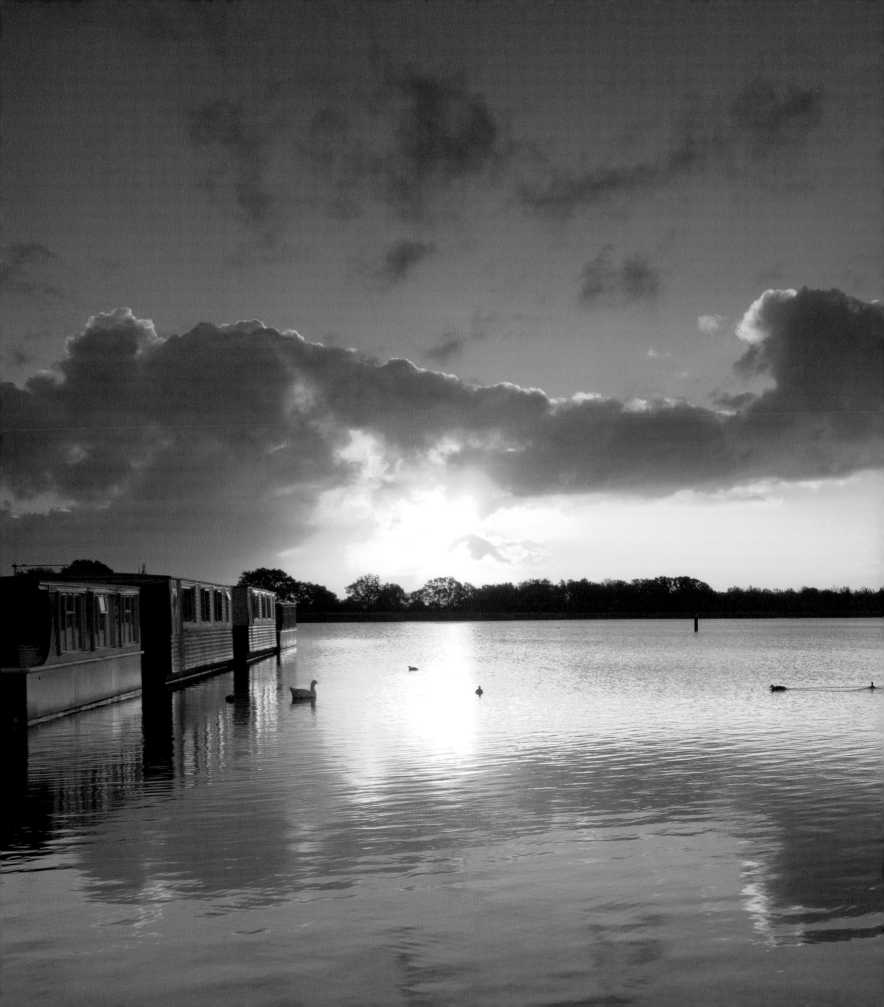

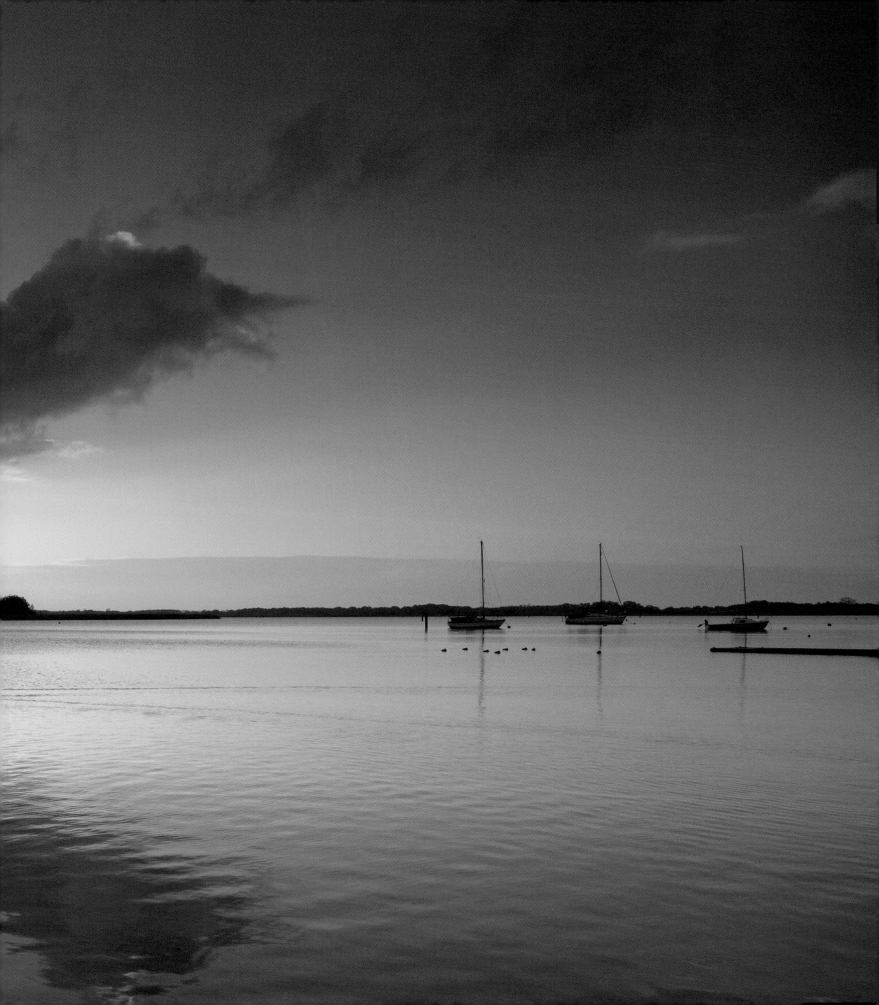

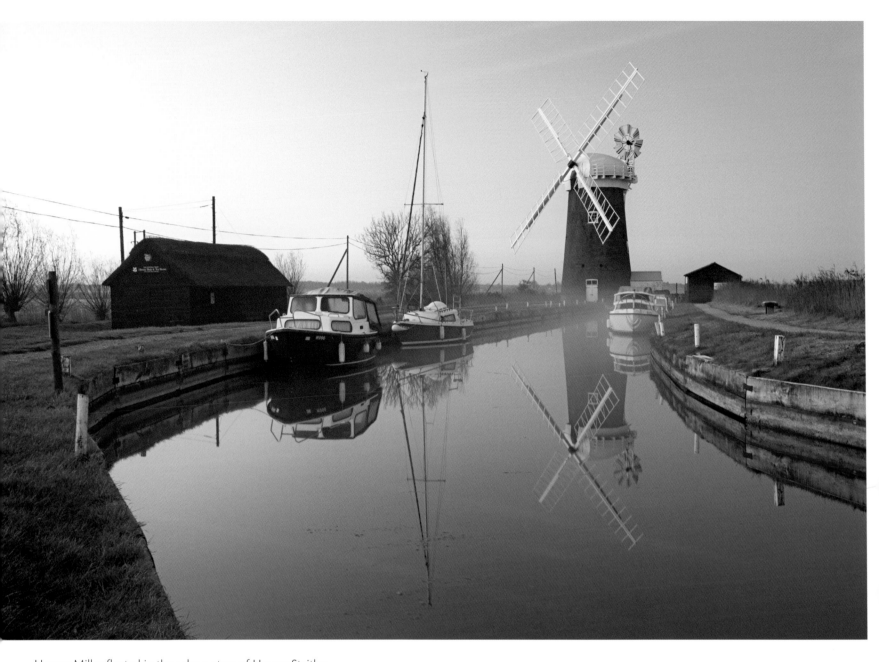

Horsey Mill reflected in the calm waters of Horsey Staithe.

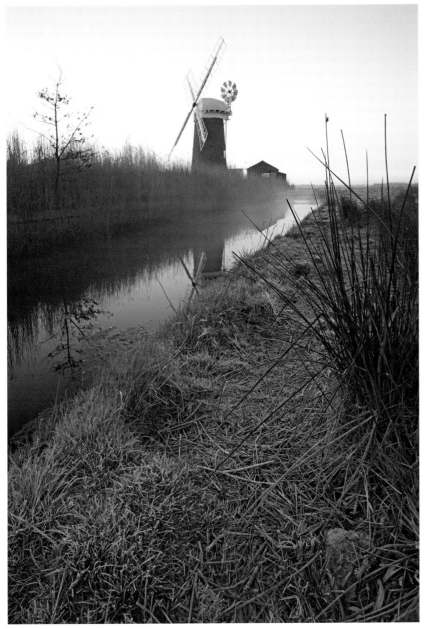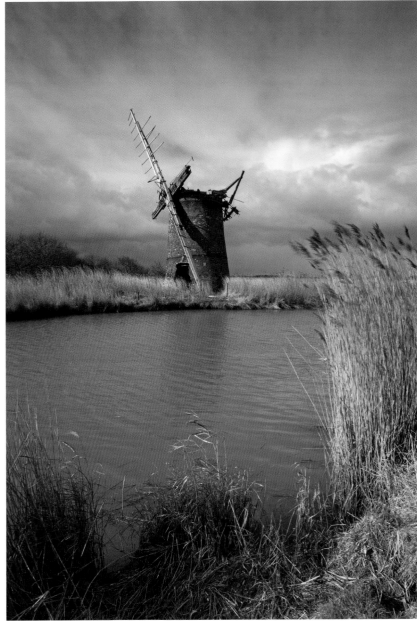

LEFT Horsey Mill is a beautifully preserved mill in the care of the National Trust. The mill dates from 1912 and replaced the original mill, which had to be demolished. It sits beside the staithe that leads off Horsey Mere and is also very close to the coast road which during the summer helps it attract numerous visitors who can climb its four storeys to gain a fine panorama over Horsey Mere. The mill is pictured here on a cold misty morning taken from beside a drainage dyke.

RIGHT Waxham New Cut leads off Horsey Mere and here you can find the beautiful derelict ruin of Brograve Mill. This is without doubt my favourite mill to photograph in Broadland. This red-brick mill dates from the 1770s and thus makes it one of the oldest mills in Broadland.

Horsey Mere can be reached via Meadow Dyke, a channel that leads from Heigham Sound near Hickling Broad. Navigation on the Mere is only possible during the summer months because of the need to preserve its important function as a place for migratory birds. This image shows a particularly dramatic sunset taken from the mere's viewpoint, reached from a path from Horsey Mill.

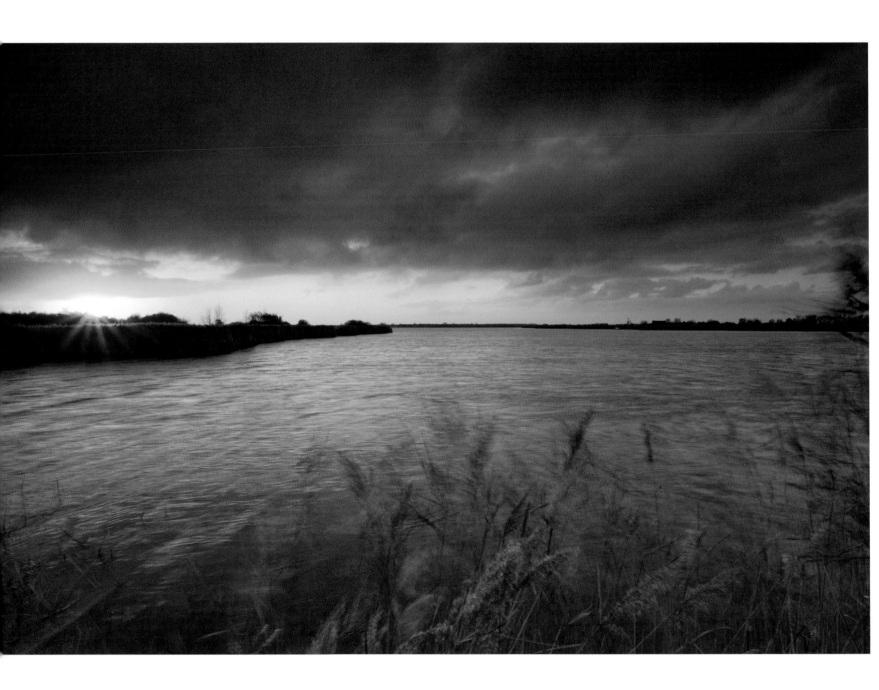

Brograve Mill is viewed here framed by golden reeds and a farmland fence on a frosty morning.

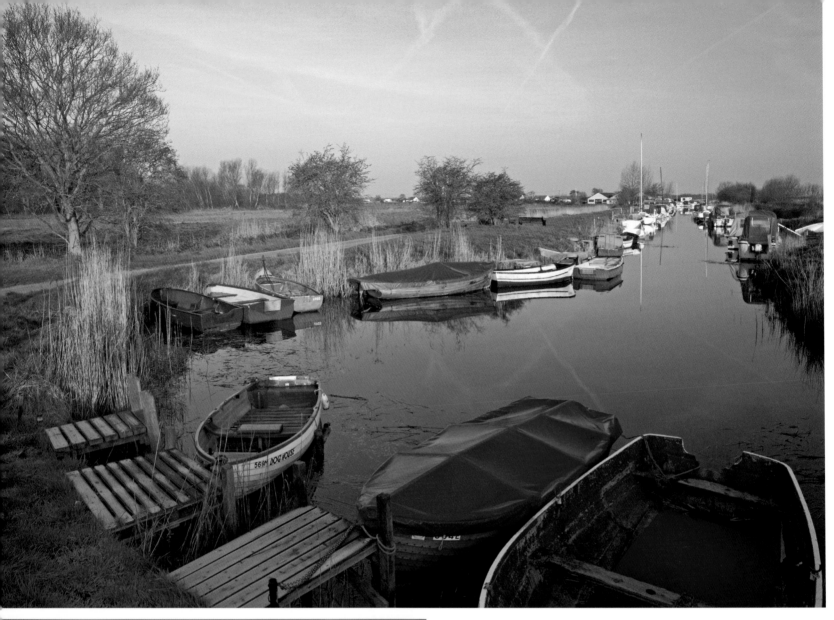

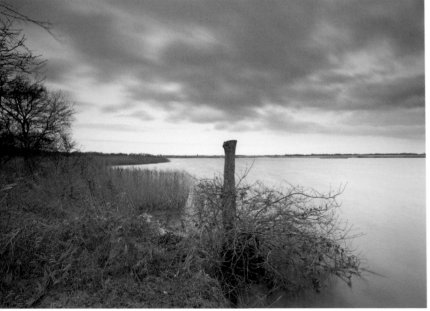

ABOVE An early morning view of Martham Staithe.

LEFT Martham Broad is at the head of the River Thurne and is a National Nature Reserve. There is a small channel that can be navigated through the Broad to reach the staithe at West Somerton.

This view on a moody winter evening is taken from the footpath that runs the length of the River Thurne's east bank which provides a lovely few hours walking in a beautiful part of Broadland.

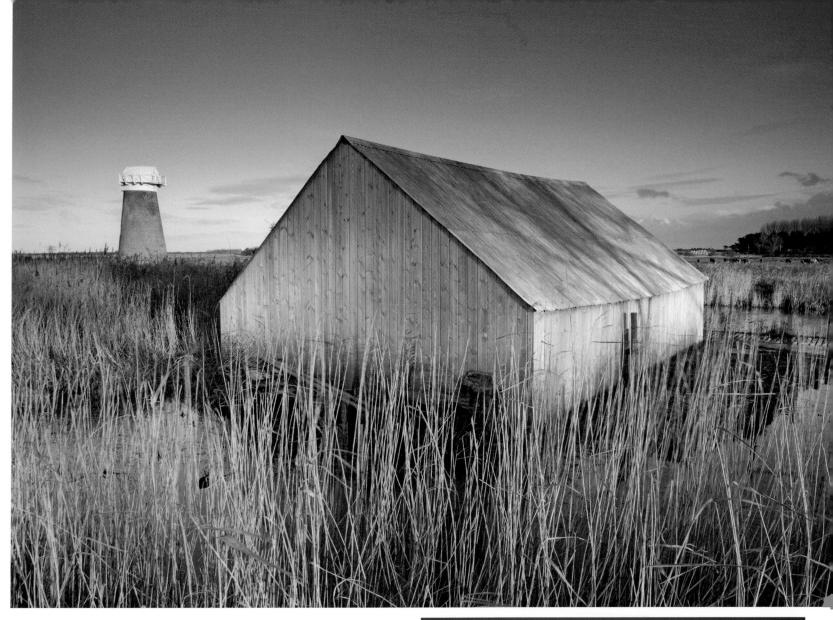

ABOVE The Boat House at West Somerton with West Somerton Mill.

LEFT A view at first light over the reed beds near Martham Broad showing West Somerton Mill.

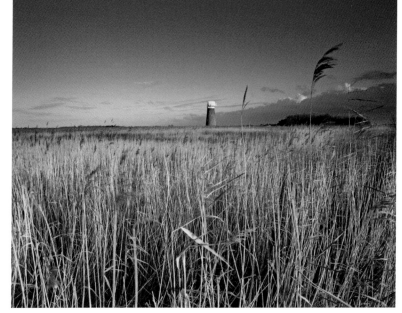

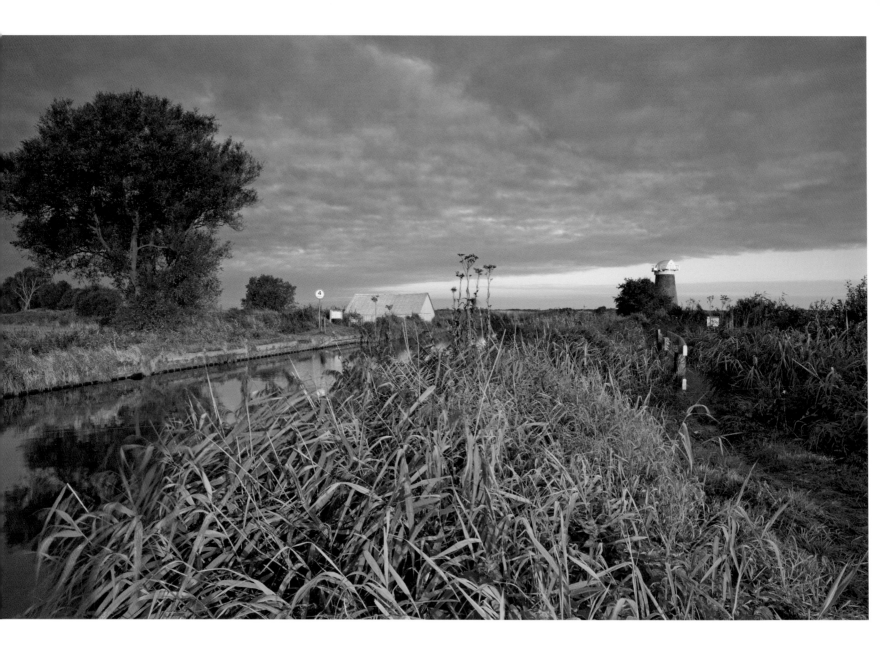

West Somerton is a favourite spot of mine because of all the photographic possibilities within a short distance. This early morning image shows the path beside the channel that links West Somerton Staithe with Martham Broad. This path runs beside the channel and eventually leads to Horsey. It is a great spot for watching migratory birds swooping in and out of the reeds in great flocks and also for spotting water deer, which frequently run across the marshes here.

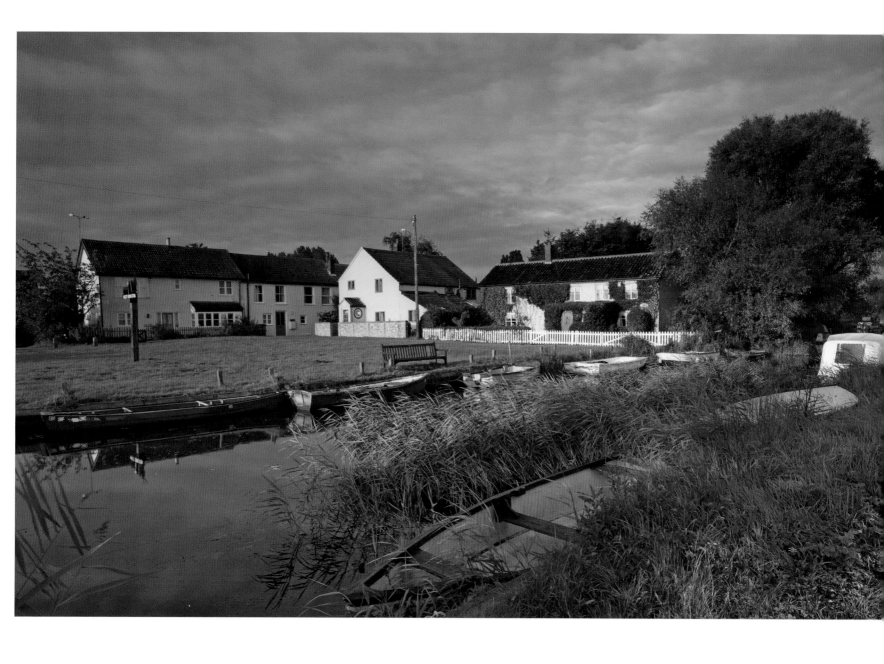

The picturesque West Somerton Staithe seen here in beautiful early light.

THE RIVER YARE

The River Yare, one of the three main rivers in the Broads, flows for 31½ miles from Norwich to Great Yarmouth, where it enters the North Sea.

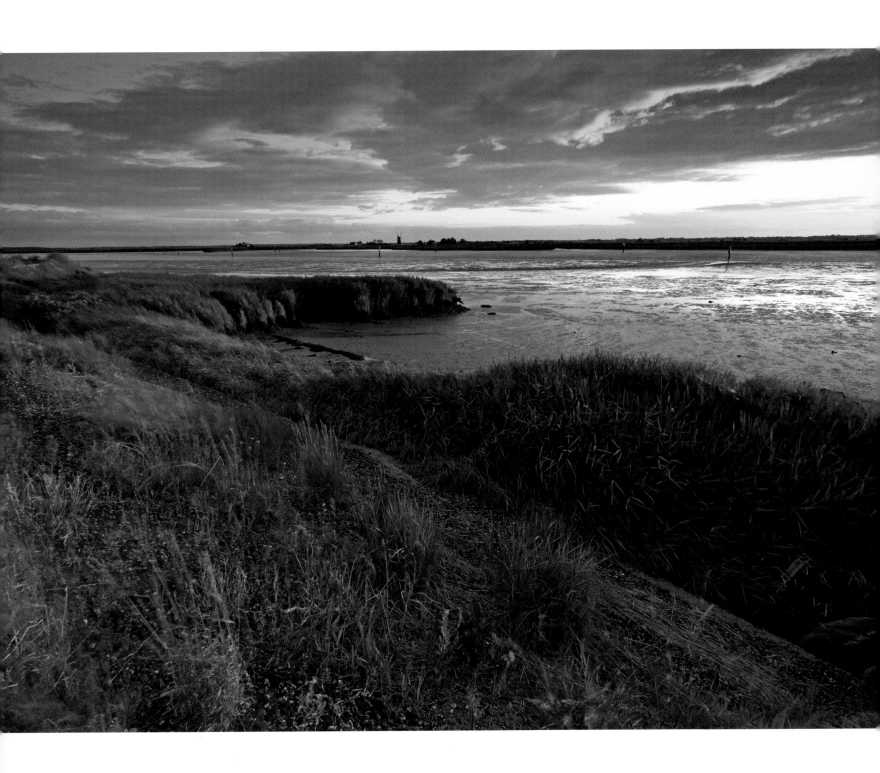

Breydon Water is the large inland estuary that the Rivers Yare
and Waveney flow into before reaching the North Sea.

This view from the very western tip of Breydon Water at
the point where both rivers converge looks across the
mudflats and water towards Berney Arms Mill.

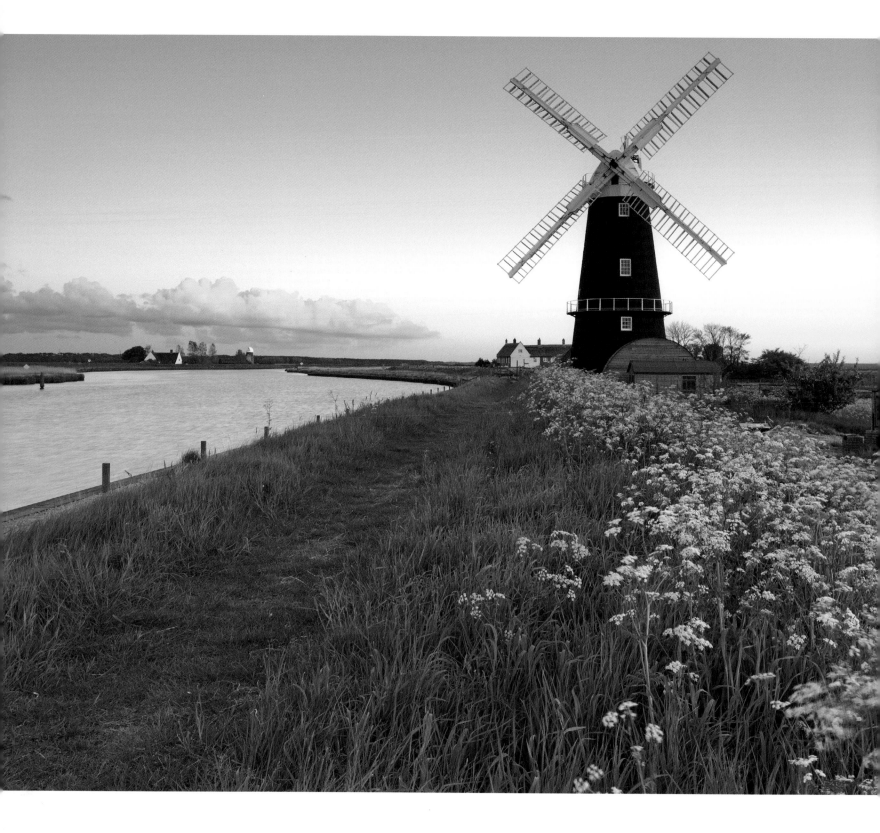

Berney Arms Mill is an iconic symbol of this part of Broadland and can be seen for miles around, especially since the refitting of its sails in May 2007. This view, taken on a late spring evening, shows the mill with, on the far bank, the mysteriously named Raven Hall and Langley Mill in the distance.

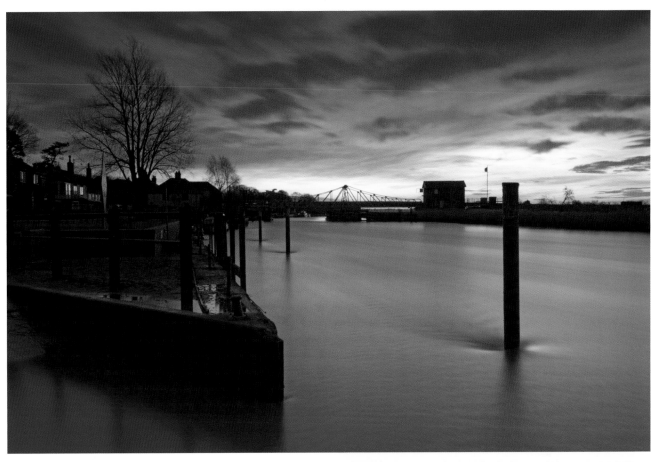

ABOVE Pre-dawn light at Reedham, 3 miles upriver from Berney Arms. Taken from the quay this view shows Reedham Swing Bridge that carries the Norwich to Lowestoft railway line.

RIGHT The Wherryman's Way footpath has some commissioned sculptures along its course. This one at Reedham shows a boat builder who would of worked in one of the numerous boatyards on the banks of the Yare. Hall's boatyard at Reedham was responsible for building numerous wherries, including the Colman family's pleasure wherry, *Hathor*.

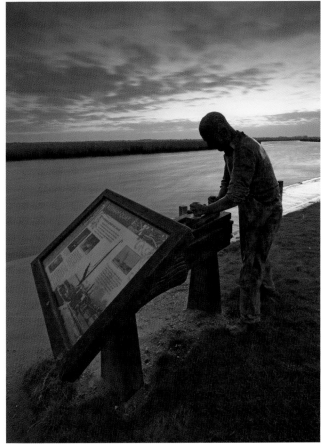

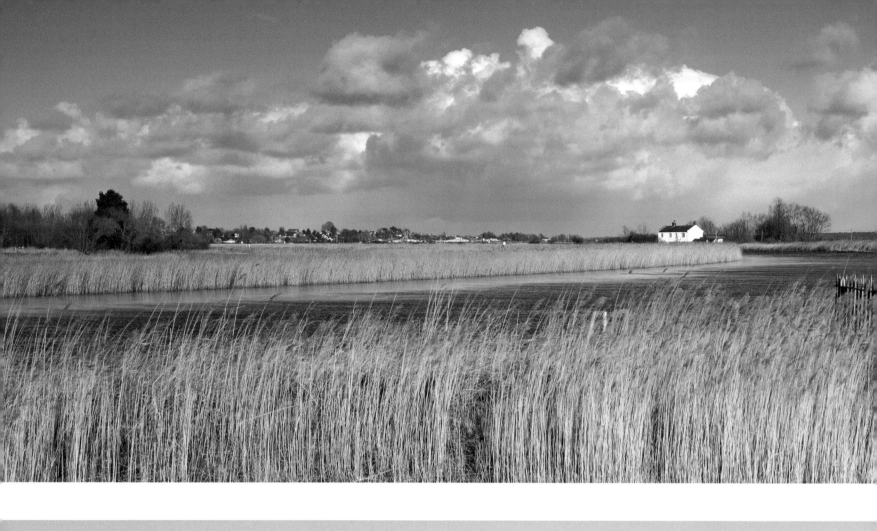

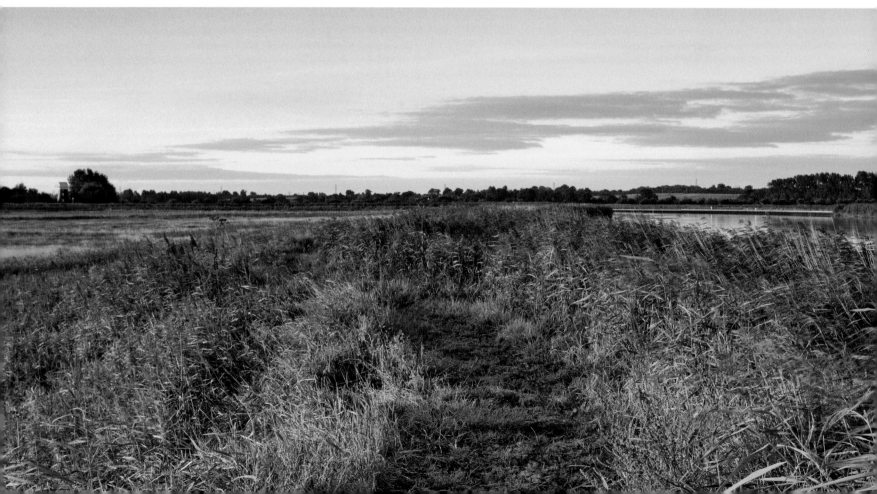

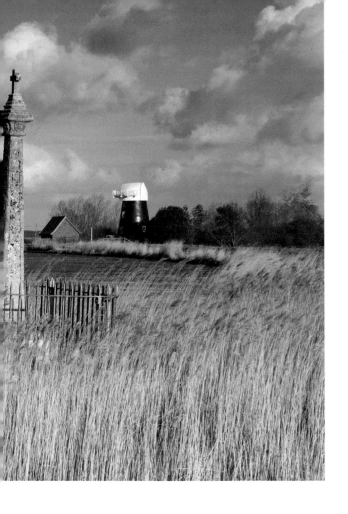

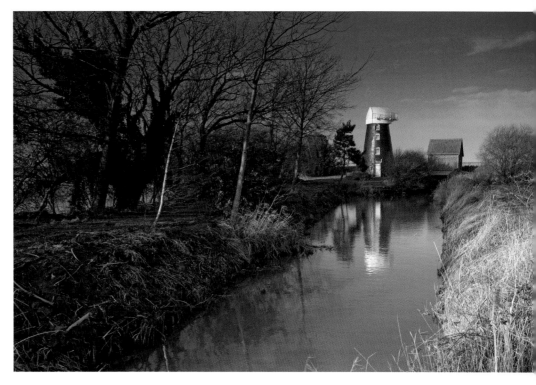

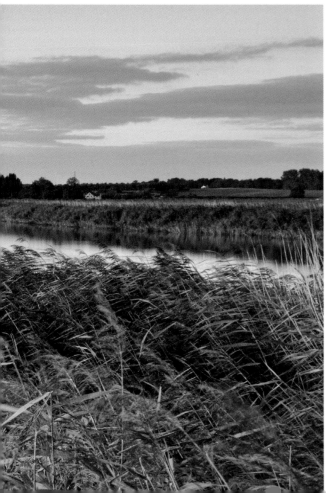

LEFT TOP About a mile down the river from Reedham is Hardley Cross. This cross marks the ancient boundary between the jurisdictions of the City of Norwich and the Borough of Great Yarmouth. It sits on the bank of the river near to the entrance to the River Chet, which is between the cross and Norton Mill in the distance.

LEFT BOTTOM Early morning light brings out the best of the colours by the riverside between Reedham and Cantley.

ABOVE Norton Mill sits beside the River Yare near to the entrance to the River Chet. It dates from 1863 and is now used as holiday accommodation.

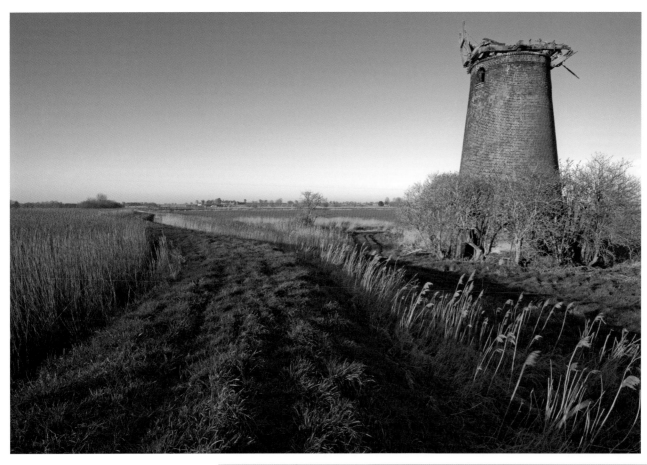

Limpenhoe Mill is situated near to the river bank at Limpenhoe Marshes. It dates from 1831 and is a possible future project for restoration.

Short Dyke connects the river to Rockland Broad and Rockland St Mary Staithe. Here it is seen in the autumn with beautiful shades in the trees and grasses lit by gorgeous early light.

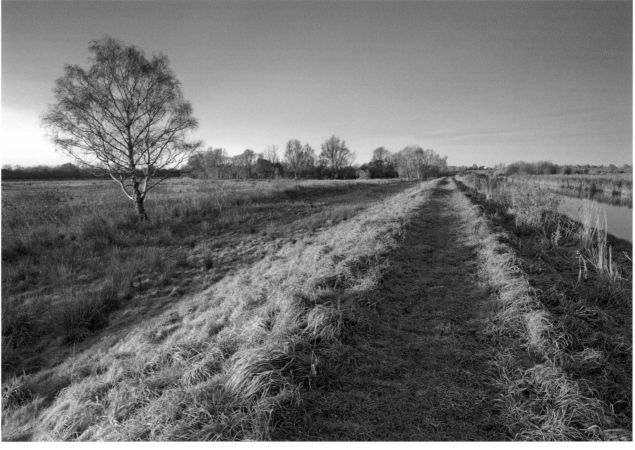

A stormy morning at Rockland Broad where intermittent snow showers and high winds plagued my attempts to get this overall shot of the Broad.

There is a part of the Broad called 'The Slaughters', where at low tide the remains of several abandoned wherries appear.

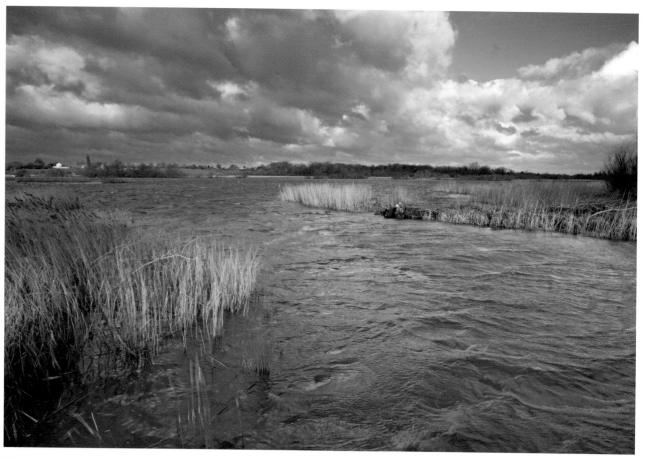

Beautiful pink hues in the sky at Rockland St Mary Staithe on a frosty autumn morning.

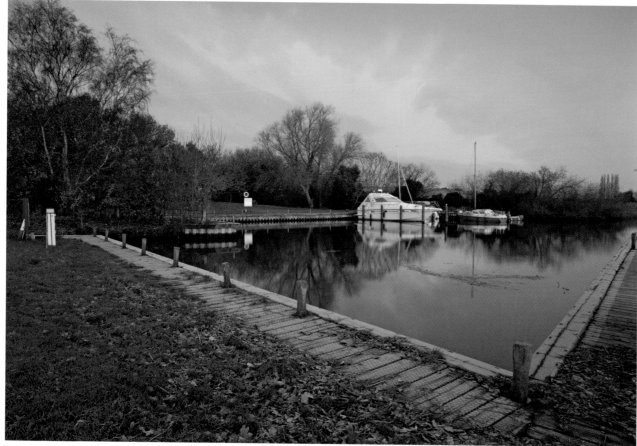

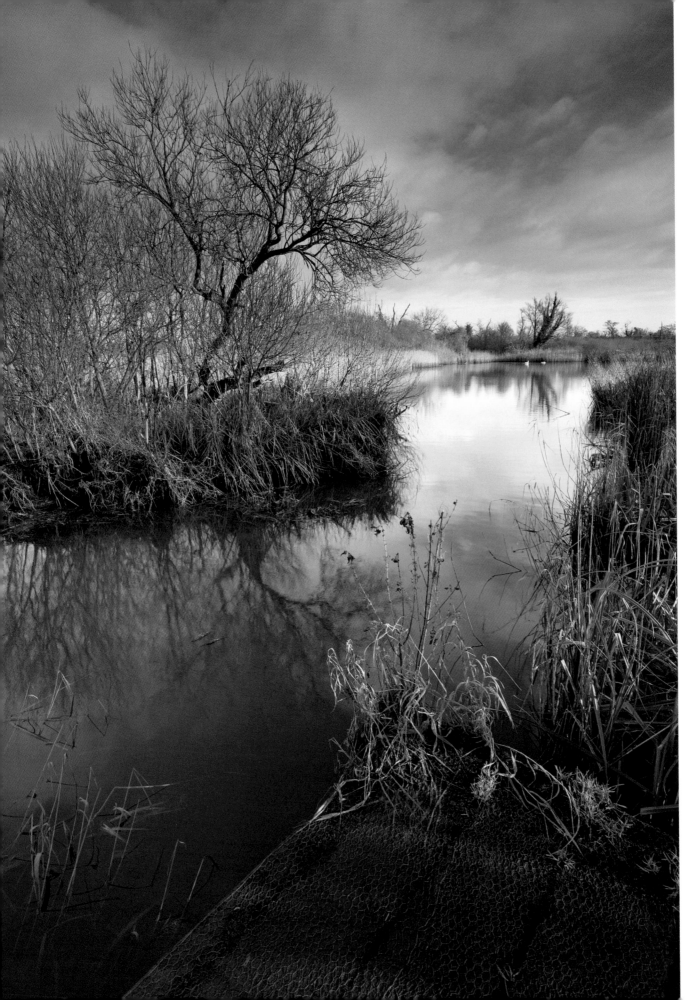

LEFT Wheatfen Nature Reserve was the home to the famous Norfolk naturalist Ted Ellis for forty years. It is now the home of the Ted Ellis Trust, who endeavour to preserve the this lovely habitat, which Ted Ellis so obsessively studied.

Two small Broads can be found in the reserve. Pictured here is Deep Waters; the other is Wheatfen Broad.

RIGHT A study of beautiful autumnal shades taken beside the river at Strumpshaw.

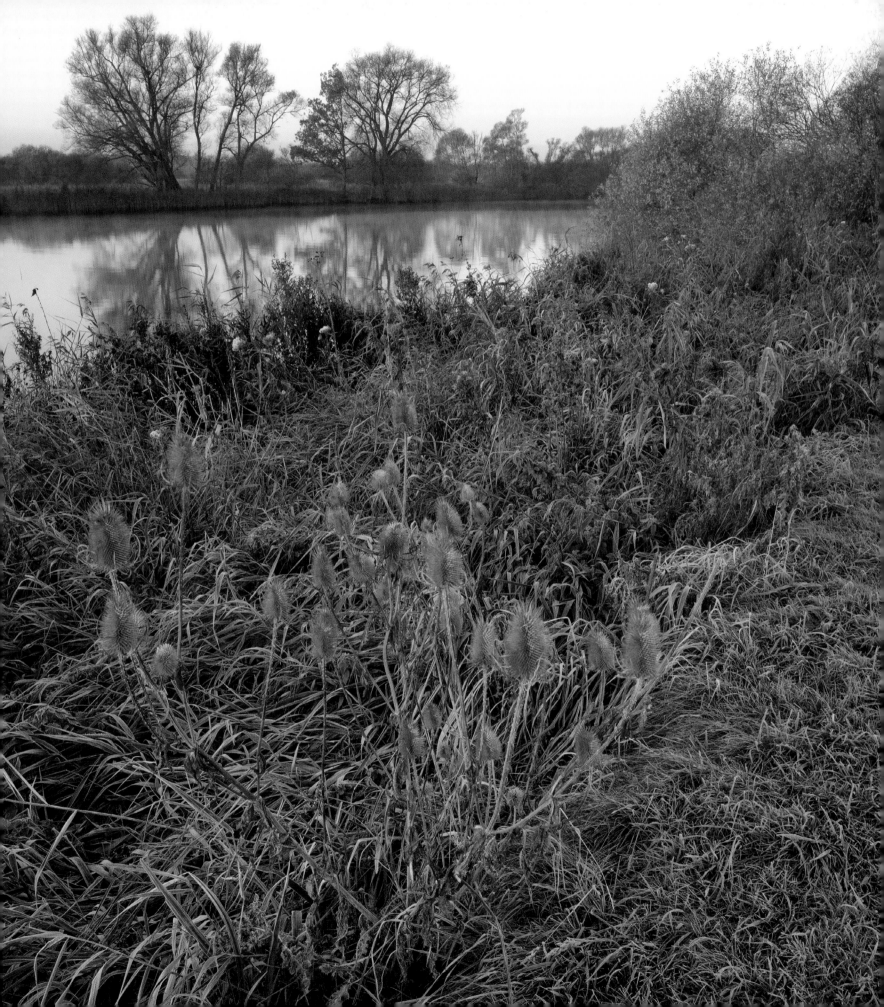

Directly opposite Wheatfen on the other side of the river is Strumpshaw Fen Nature Reserve, which is in the care of the RSPB. This is a prime location for viewing some of the famous birdlife associated with the Broads, such as marsh harriers, bitterns, kingfishers and barn owls.

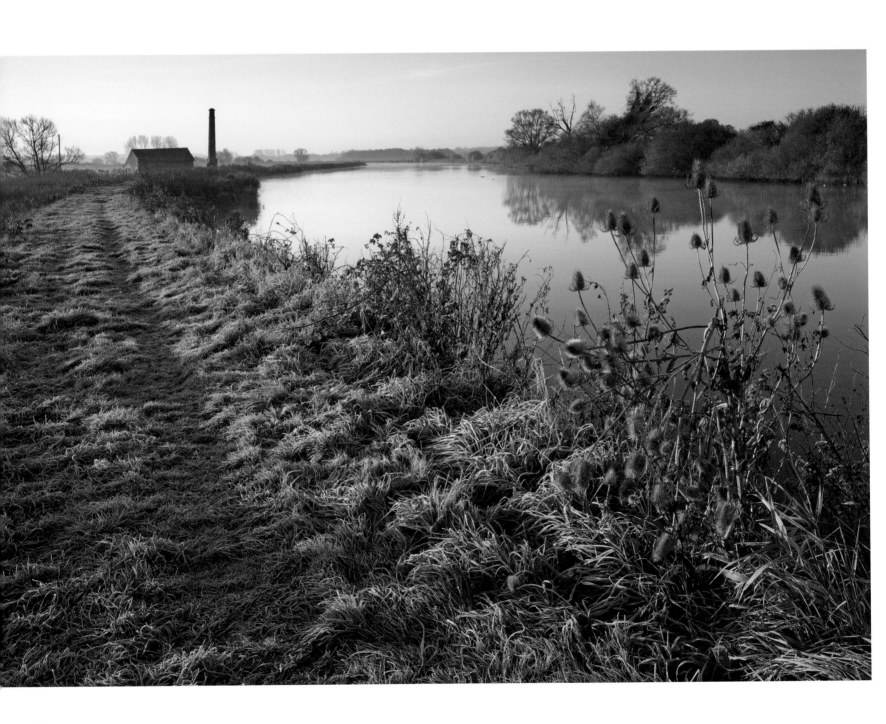

A cold and misty morning overlooking Strumpshaw Broad in Strumpshaw Fen Nature Reserve.

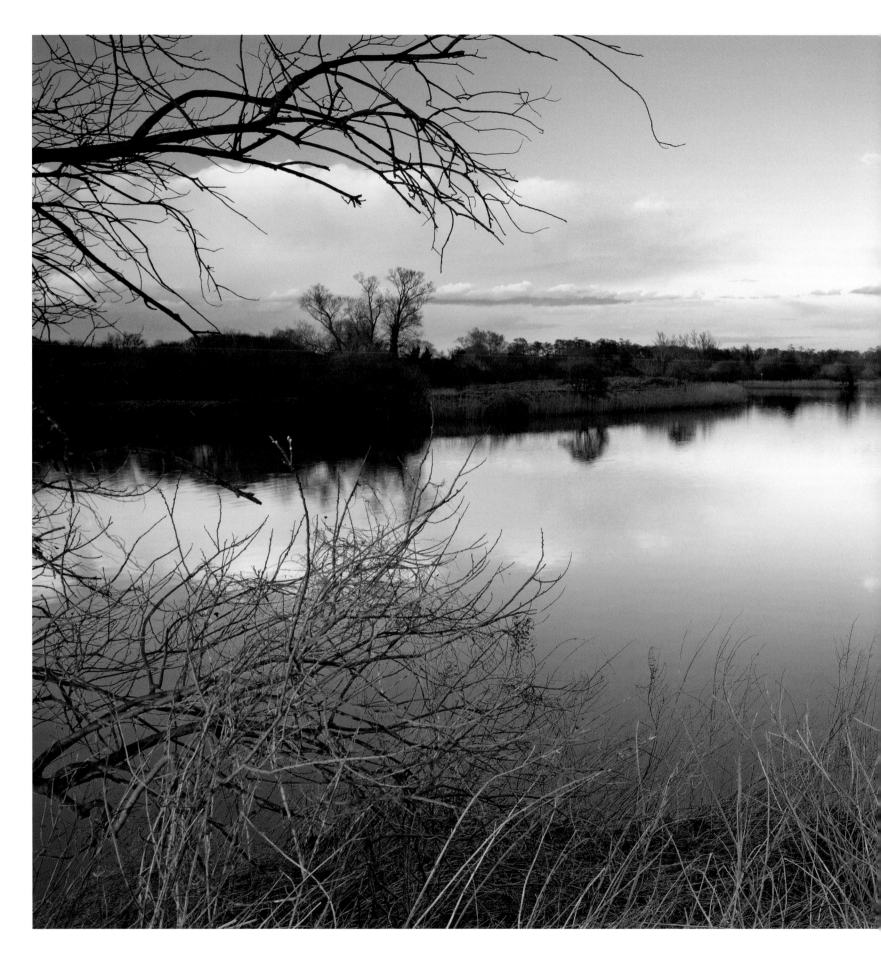

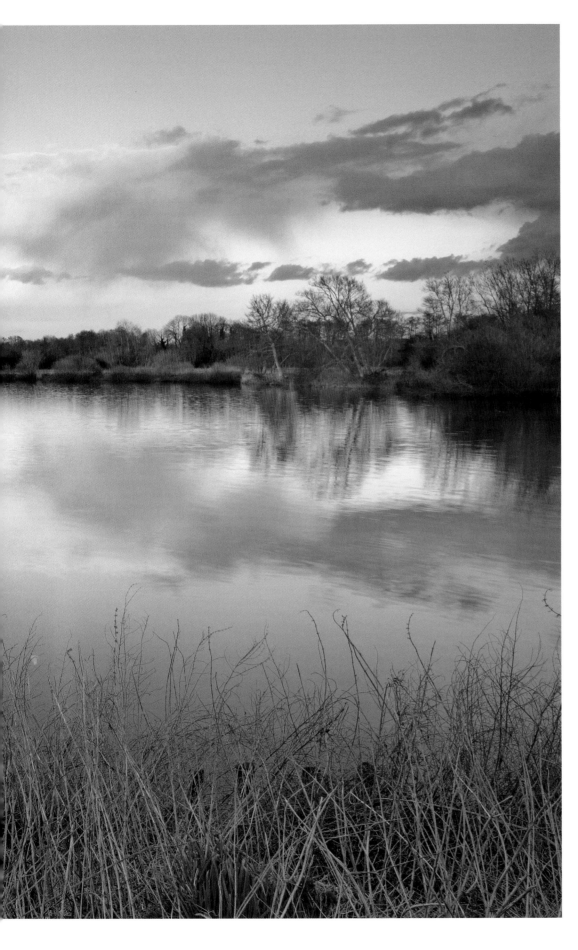

Light blue and magenta shades in the sky and the last light hitting the riverside trees produce this beautiful end-of-the-day scene at Surlingham.

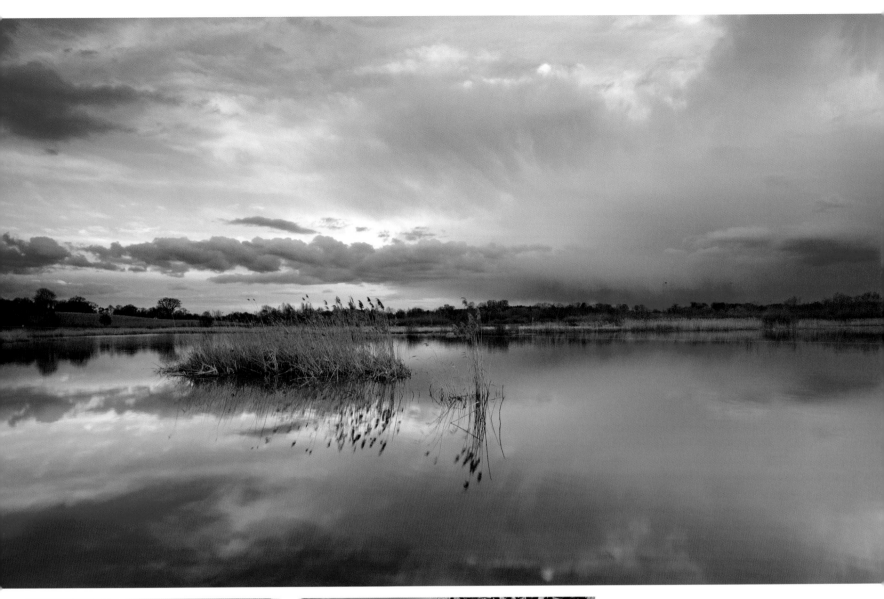

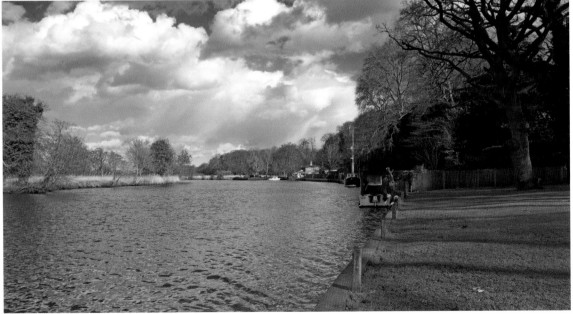

ABOVE A blue-toned sky reflected in this calm stretch of open water at Surlingham Church Marsh Nature Reserve.

In the distance, behind the small island of reeds, is the ruin of St Saviour's Church, where Norfolk naturalist Ted Ellis is buried. The site of the church is on higher ground and offers a fine panorama of the Yare valley.

LEFT Bramerton is a picturesque village beside the Yare, approximately 3 miles from Norwich. At Bramerton Woods End, just outside the pub of the same name, there is a statue of the local character Billy Bluelight, who was famous for challenging boats to a race along the Yare.

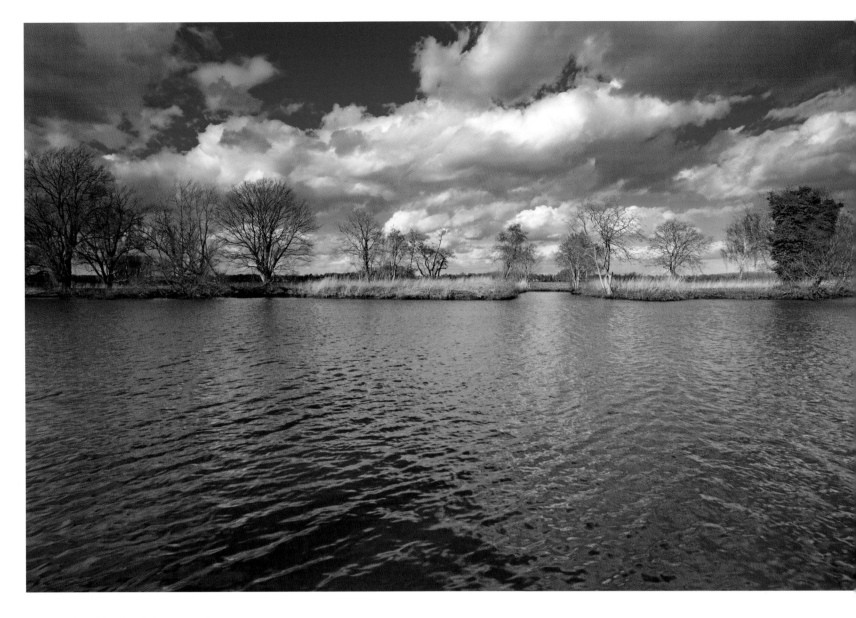

The tree lined banks of the Yare at Bramerton on a
moody winter afternoon.

OVERLEAF Whitlingham Country Park is an ongoing
development, whch has created a beautiful peaceful area to
indulge in country walks around Whitlingham Great Broad or
to try your hand at a water-based sport at the Outdoor
Education Centre.

The Great Broad pictured here was created by flooding old
gravel pits. The picture also shows a sculpture influenced by
the distinctive shape of the sails of the wherries. In the
distance is the city of Norwich.

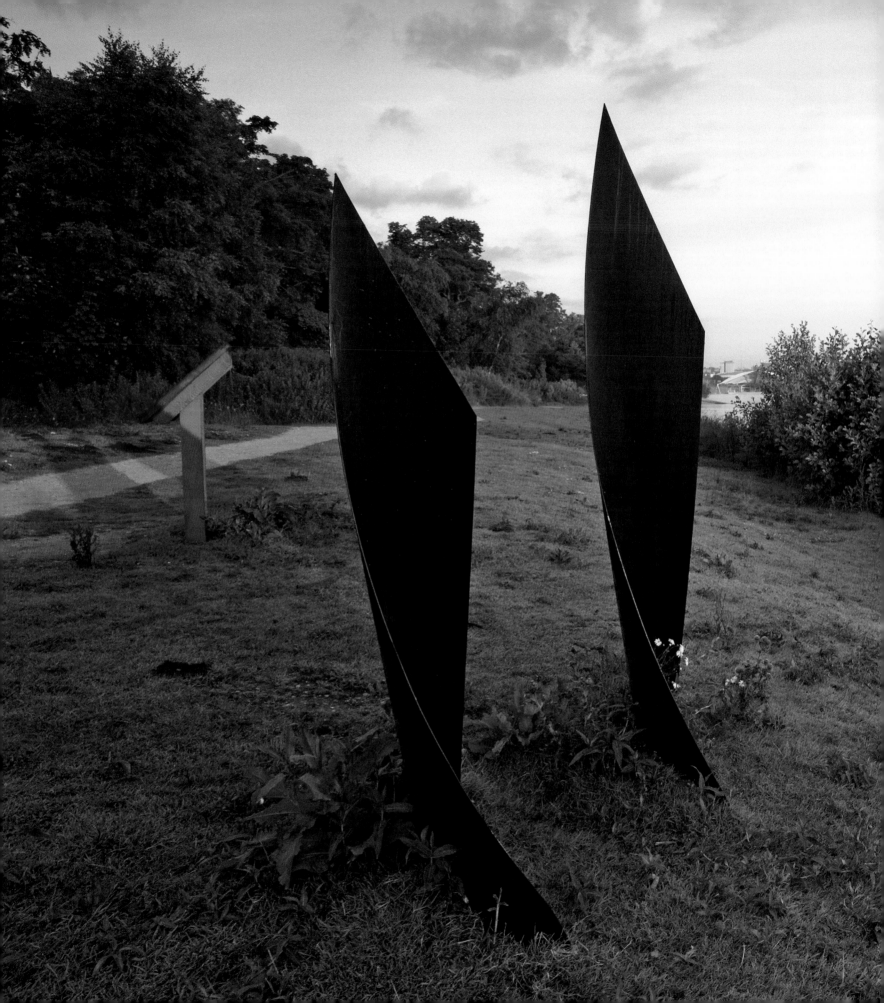

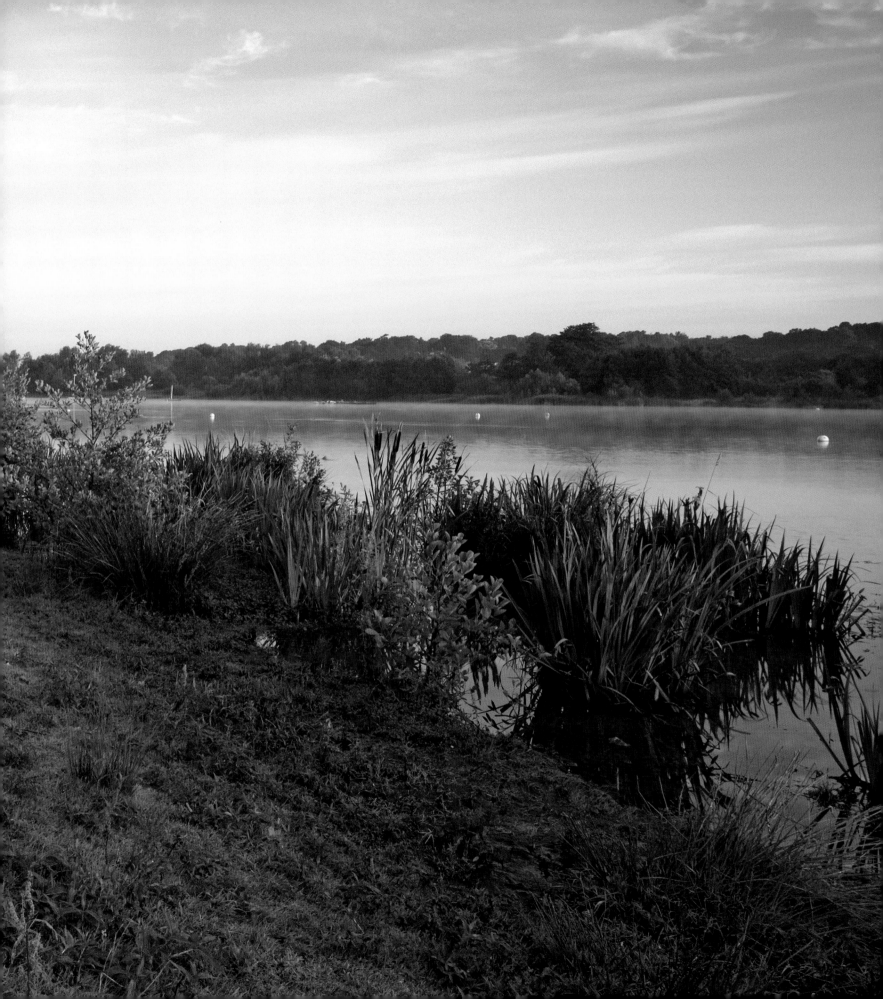

THE RIVER CHET

The River Chet is a tributary of the River Yare, joining it at Hardley Cross after a 3½-mile journey of its navigable section from the market town of Loddon. It is bordered for part of its length by Hardley Flood, which is a spillway and designated as a Site of Special Scientific Interest due to its abundance of wildlife.

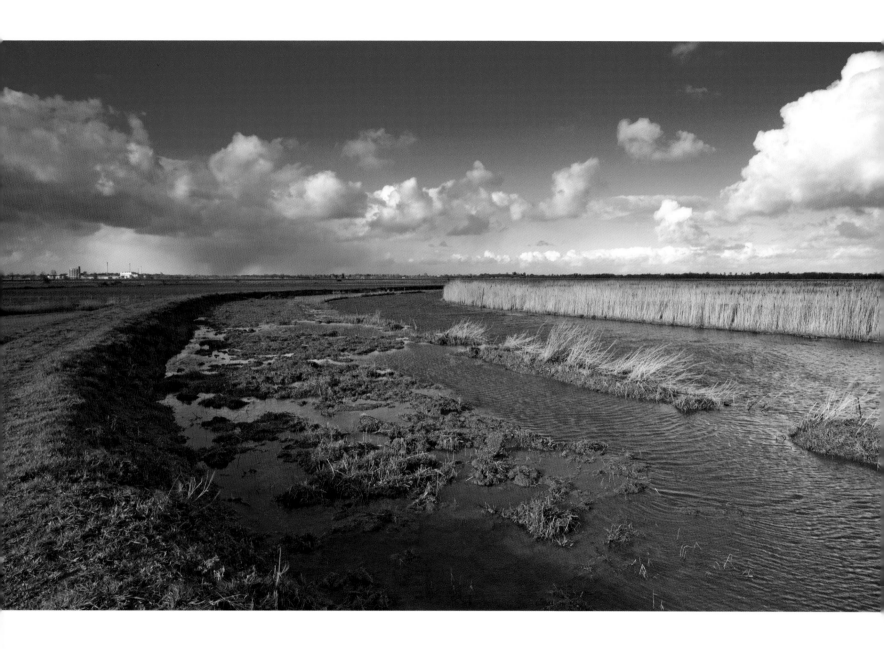

Wide views across the Yare valley can be witnessed from the River Chet as it branches off from the River Yare. High water in this shot has flooded the banks of the river; note the use of the red markers to ease navigation. In the distance is the Cantley Sugar Factory, which is visible for miles around in this part of Broadland.

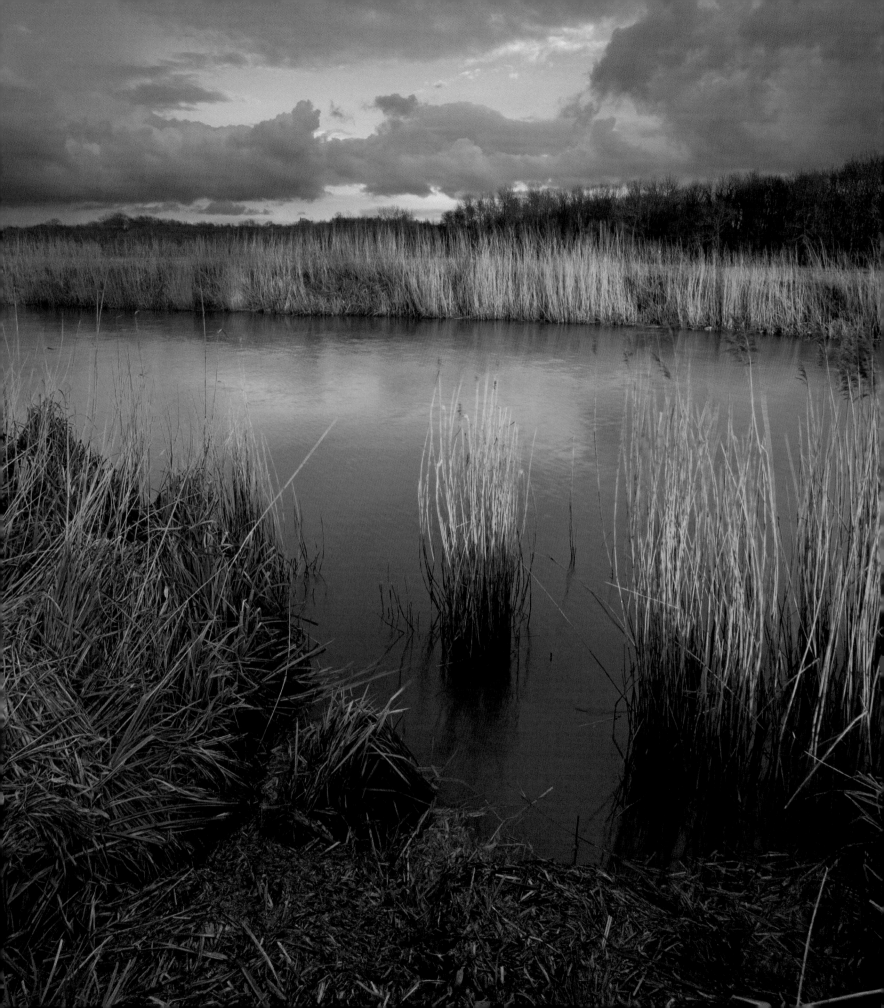

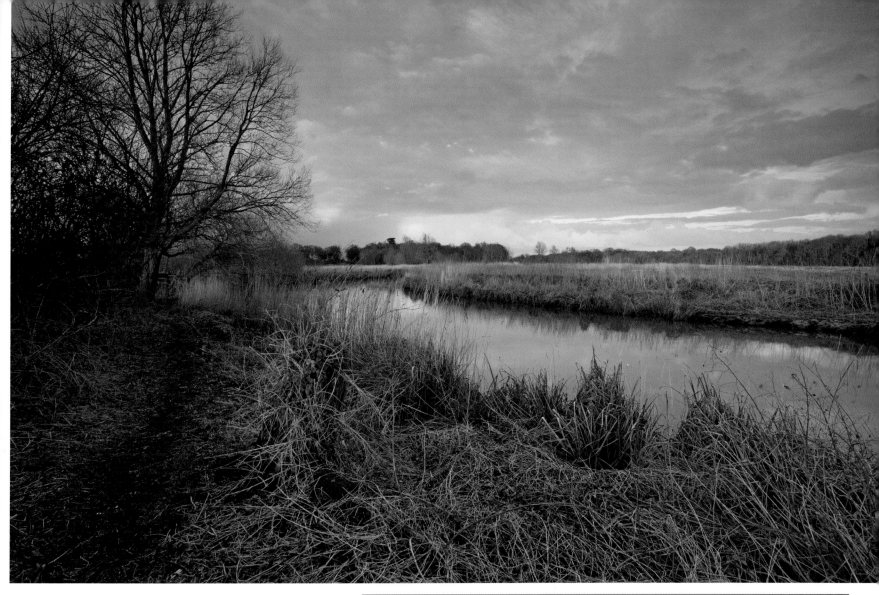

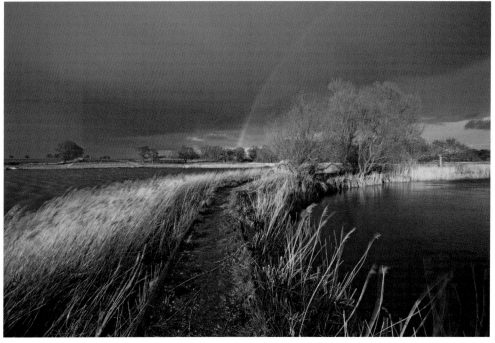

LEFT The initial open landscape of the river gives way to a more wooded landscape as the it reaches the area around Hardley Flood. Here late-evening light illuminates the scene by the riverside near Hardley Flood.

ABOVE Another shot by the banks of the river in beautiful late evening light.

RIGHT A rainbow appears in the sky above Hardley Flood on the left and the River Chet on the right after a storm had passed over the area.

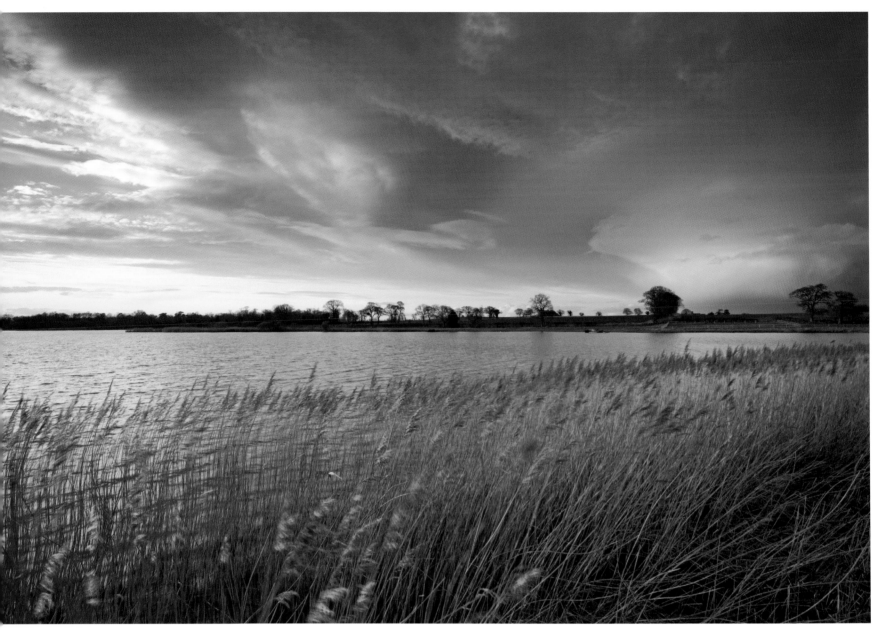

After the passing of a storm, beautiful clouds form over
Hardley Flood as sunlight hits the reeds at the water's edge.
This nature reserve appeared as a result of the flooding of
agricultural land in the 1940s. It is a haven for wildlife and the
nature of the tides and flooding from the River Chet can
leave it as either a large expanse of water or mud.

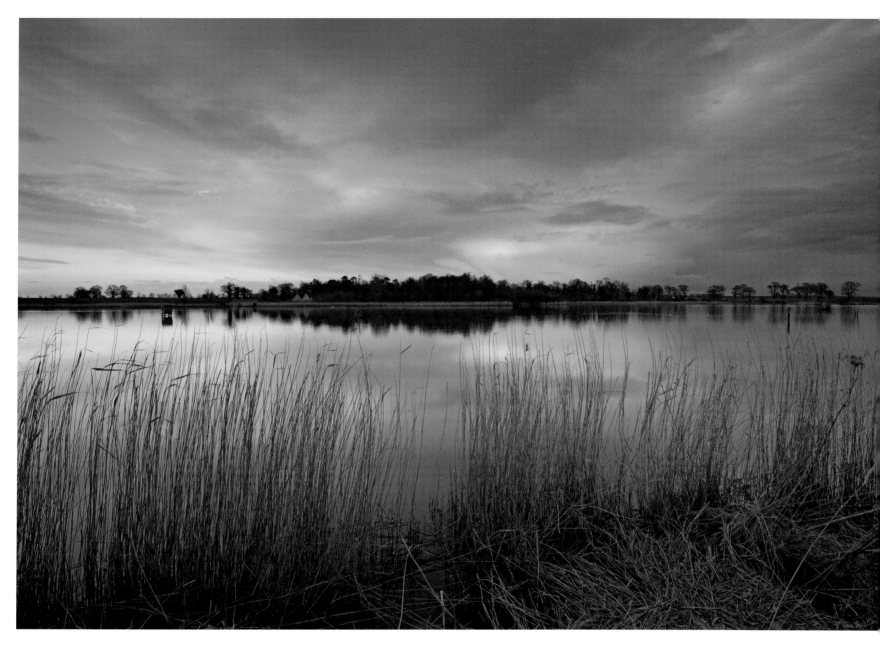

A beautifully dramatic sky hangs over the still waters of
Hardley Flood at the end of the day.

OVERLEAF The attractive market town of Loddon is a lovely
place to stroll and admire some of the beautiful houses that
line its main street. This view is of the staithe at Loddon near
to the end of the navigable portion of the Chet.

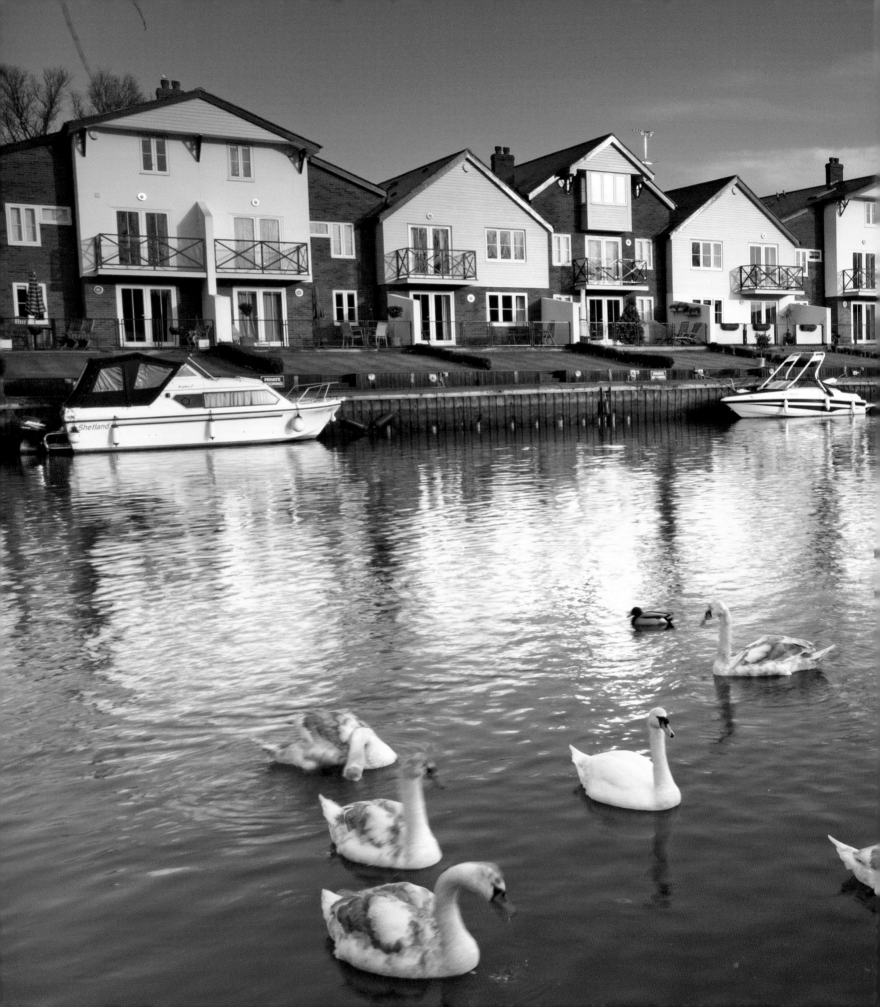

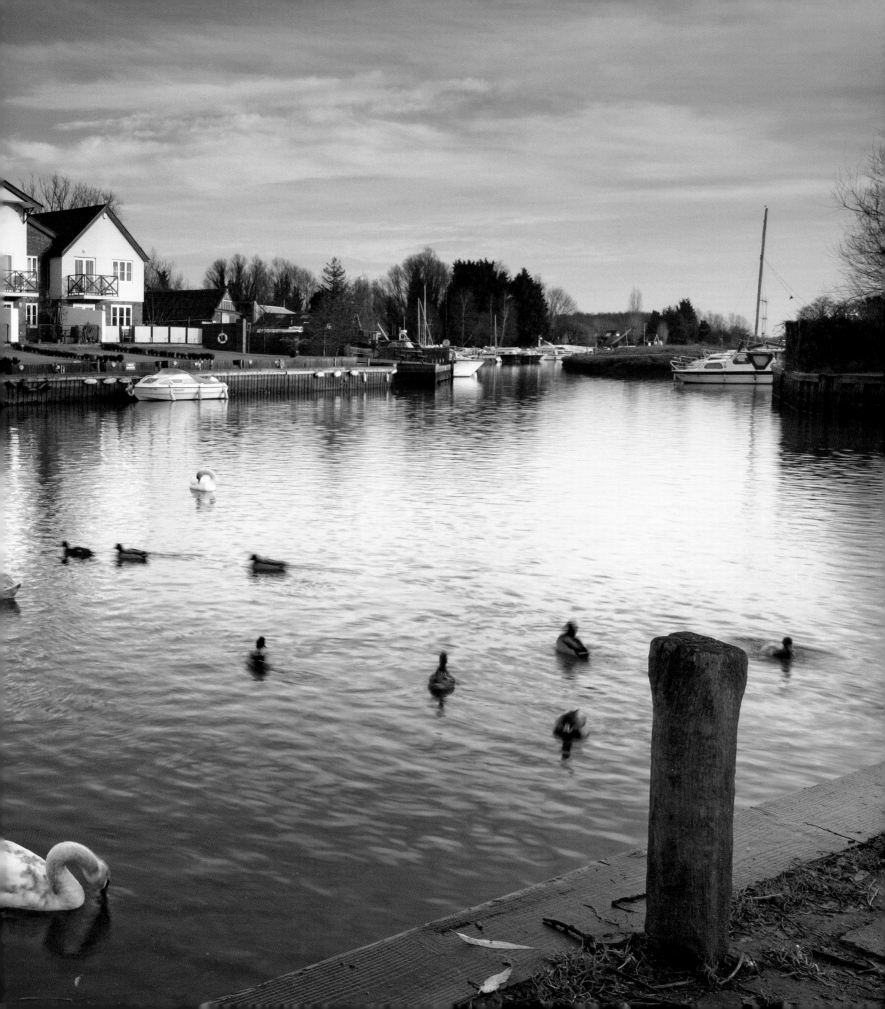

THE RIVER WAVENEY

The River Waveney, one of the three main rivers in the Broads, begins its navigable journey at Geldeston Locks and continues for 21½ miles until it reaches Breydon Water near Great Yarmouth alongside the River Yare.

The impressive walled ruins of the third-century Roman fort at Burgh Castle overlook the Waveney and Yare rivers as well as Breydon Water and Halvergate Marshes.

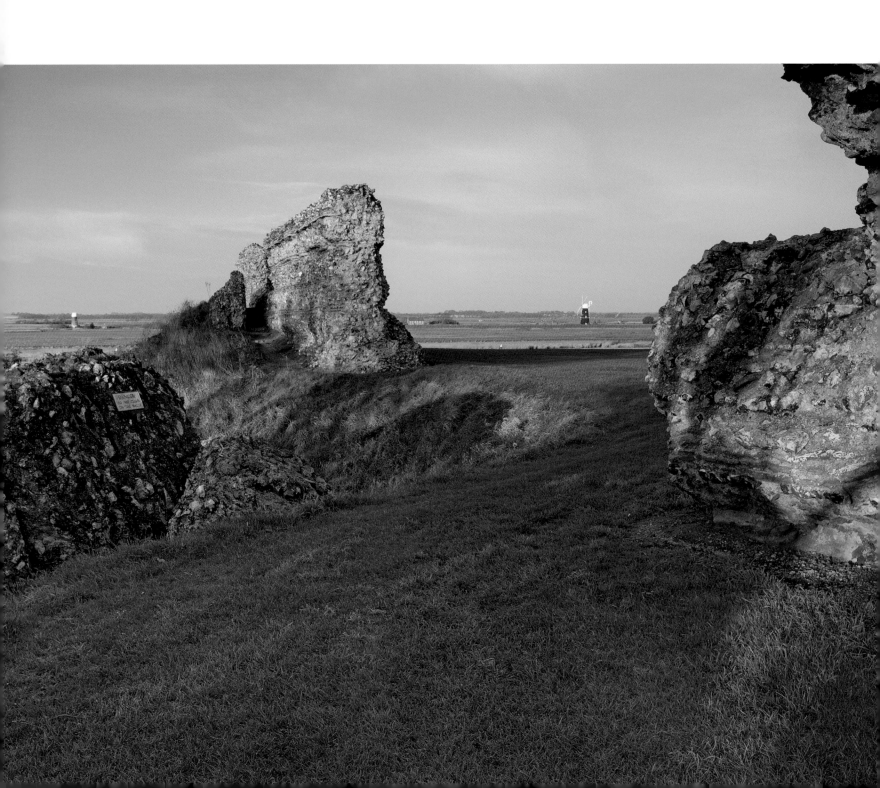

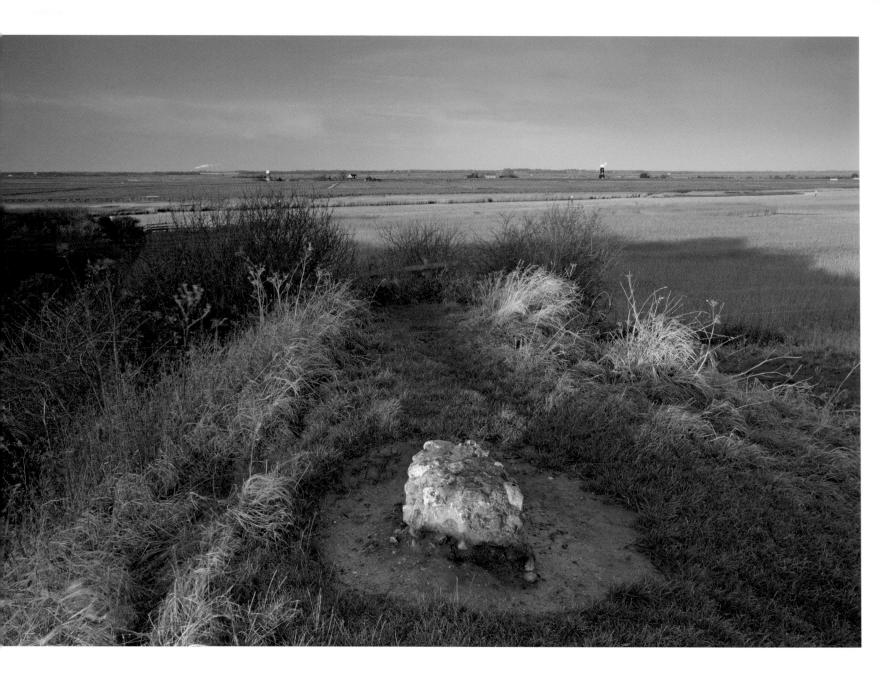

Another view from Burgh Castle towards the isolated
settlement of Berney Arms, showing the towering Berney
Arms Mill, which dominates the skyline. In the distance to the
left of the mill can be seen a smoke plume from Cantley
Sugar Factory, which dominates its own part of Broadland.

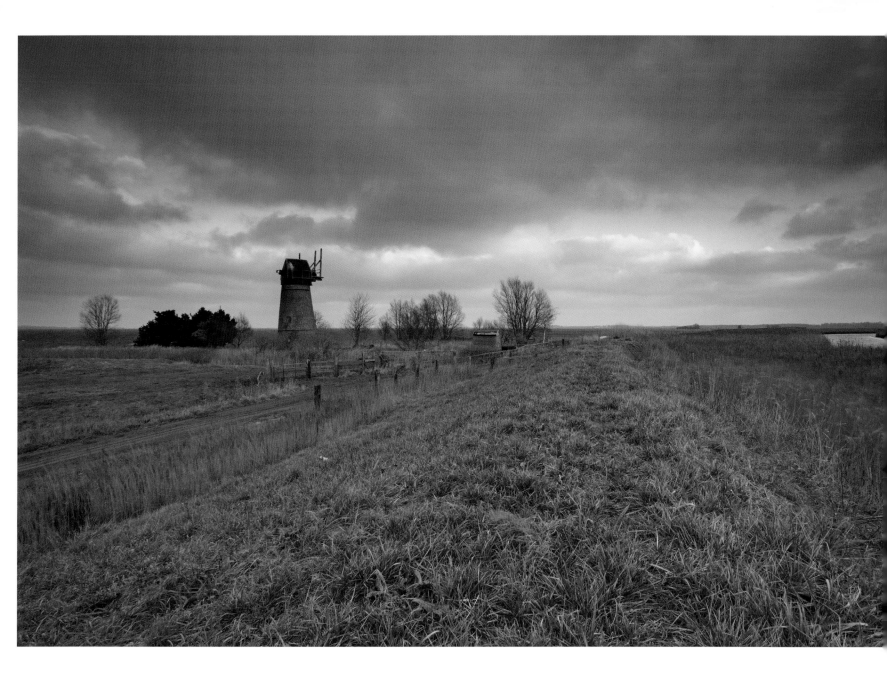

A moody morning beside the River Waveney on Haddiscoe Island near St Olaves with the smallest of patches of sunlight temporarily illuminating Toft Monk's Mill. Haddiscoe Island was formed by the creation of a channel between the River Yare and River Waveney which opened in 1832. The merchants of Norwich had grown tired of the slow speed and expense of transporting goods to and from Great Yarmouth so they created the channel to make access to a new port which would be developed in the then coastal village of Lowestoft in Suffolk.

After St Olaves the river meets the Norfolk and Suffolk border near Herringfleet and then itself becomes the border. Herringfleet Mill, which sits beside the river on the Suffolk side of the border, is the only surviving smock mill in Broadland, and dates from the 1820s.

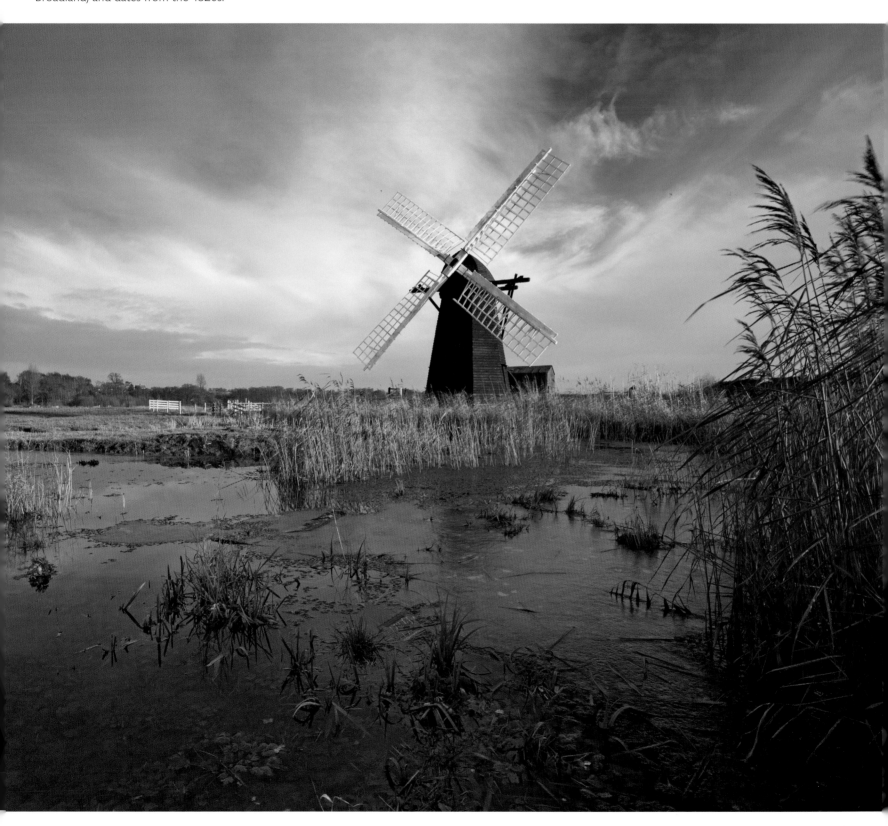

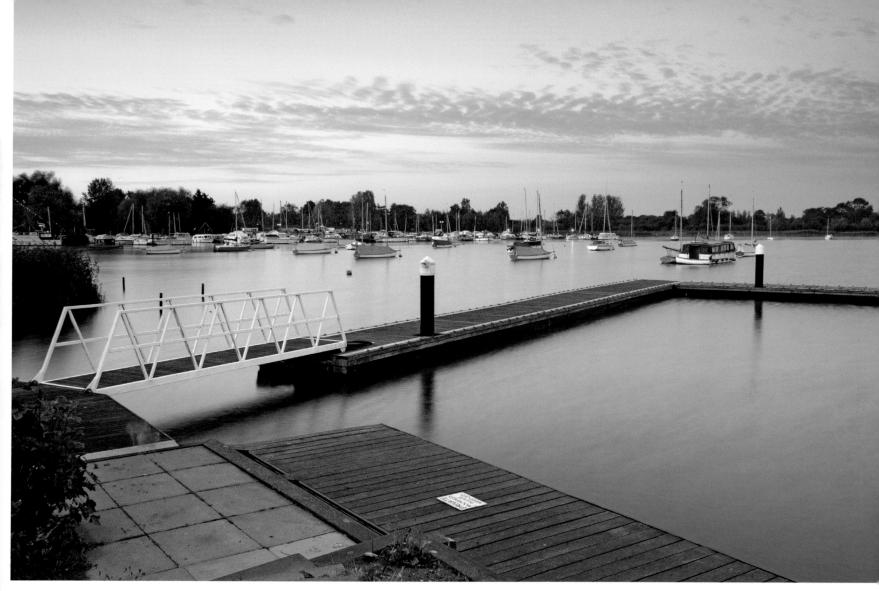

ABOVE A couple of miles upriver, Oulton Dyke branches off from the river and leads to Oulton Broad, which is known as the Southern Gateway to the Broads. There is a beautiful riverside park here, with lovely views over the Broad. This picture shows the moorings at Oulton Broad at dawn.

RIGHT A wider view of the Herringfleet area on a stormy winter's day as the last light of the day forces its way through the ominous looking clouds. The higher ground on the left of the picture is known as the Herringfleet Hills and is a perfect place to have a stroll in the countryside and look down on the Waveney valley. If the fields are not too flooded you can walk to Herringfleet Mill by the riverside.

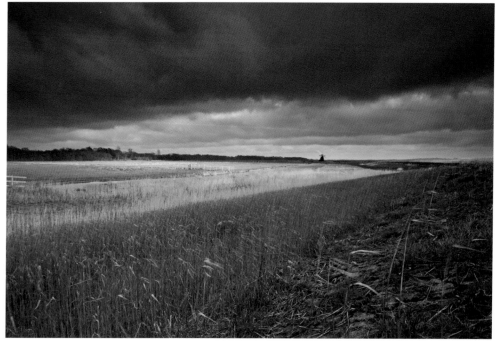

A beautiful sunrise at Oulton Broad. This spot is immensely
popular for fishing and two brave souls have braved the cold
morning in the hope of a catch. Across the water the
impressive old wharf buildings are now apartments.

As well as the chance of seeing sailing boats from the local
club racing on the broad there is also a regular programme of
powerboat racing here.

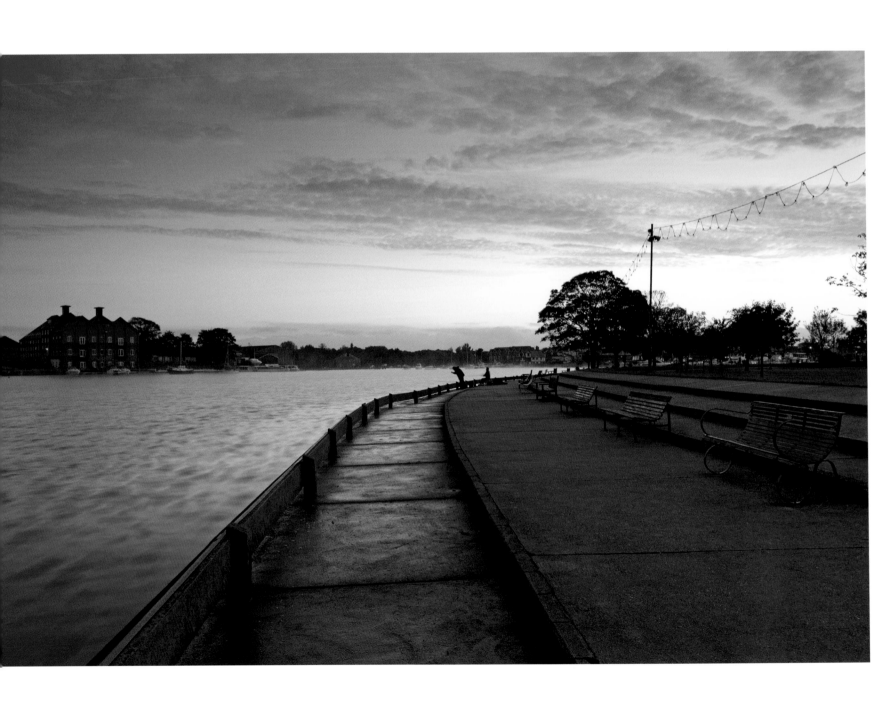

A view of the river taken near Barnby with the remnants of the previous night's light snowfall melting away among the reeds.

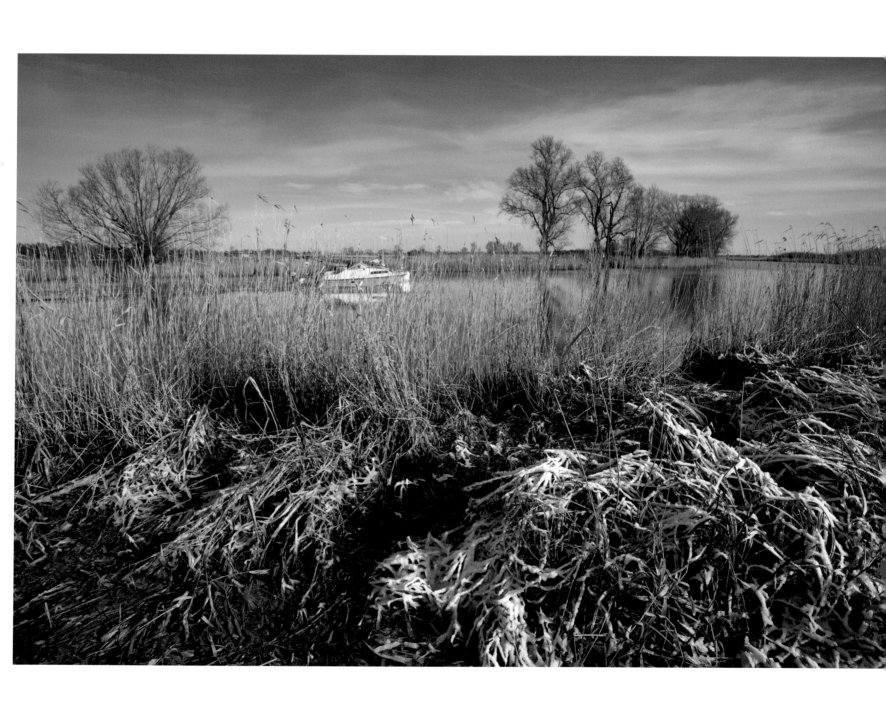

Boathouse Hill is an idyllic scene beside the river, a short distance from Beccles.

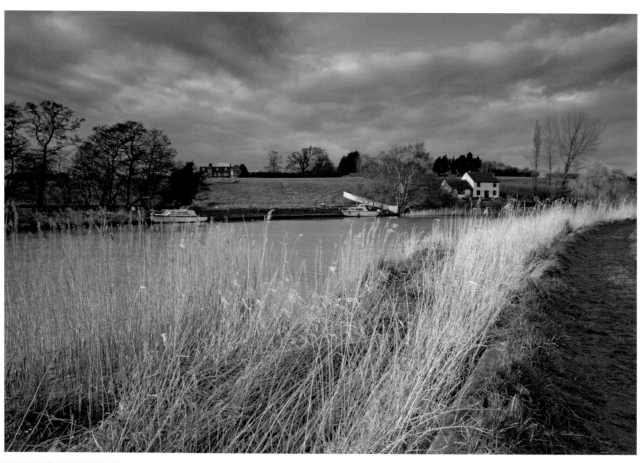

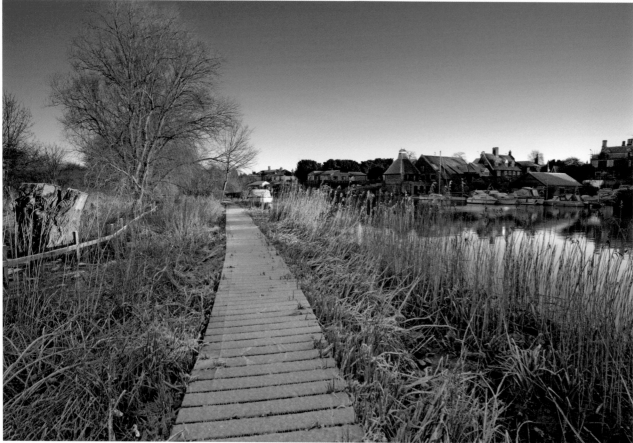

A riverside pathway view of the Suffolk market town of Beccles gives lovely views across the water of the town and its elegant buildings, many of which are from the Georgian period.

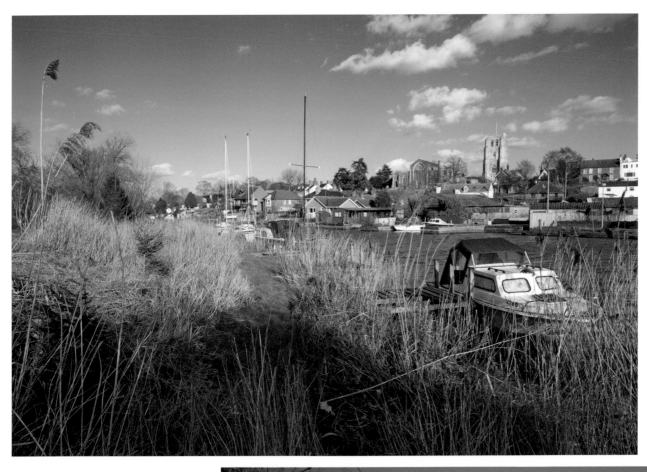

Another view of the riverside at Beccles, this time showing its most prominent feature, the 97-foot sixteenth-century belltower that stands separately from St Michael's Church. The tower is also built at the wrong end of the church near to the altar because of worries that its sheer weight may have caused a collapse if it were built in a precarious position on the cliff's edge.

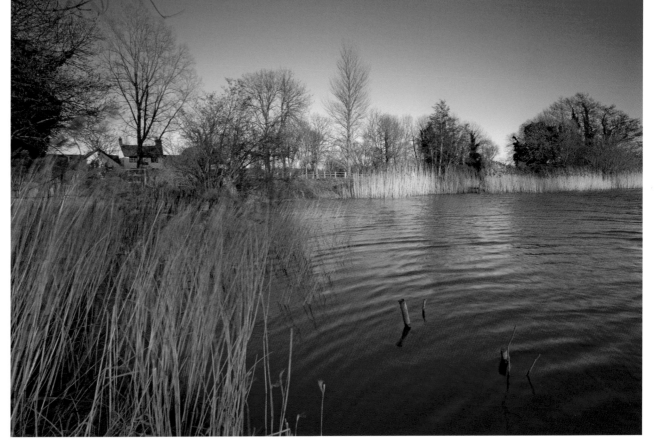

Glimpsed here through the reeds, Geldeston Locks Inn is the marking point for the limit of navigation of the river. It has been a public house since the seventeenth century.

OVERLEAF Just beyond the limit of navigation at Geldeston Locks is this beautiful scene, in this instance bathed in the late afternoon light of a clear winter's day.

THE TRINITY BROADS

The name Trinity Broads is a little misleading as this area consists of five broads that are interconnected but not connected to any of the main Broads rivers. In 1998 they were recognised as a Site of Special Scientific Interest. The five broads are Ormesby, Rollesby, Ormesby Little, Filby and Lily. Their isolation from the main river system means that they are less prone to suffering an abundance of nutrients in the water which can lead to growth of algae and a reduction in the quality of the water.

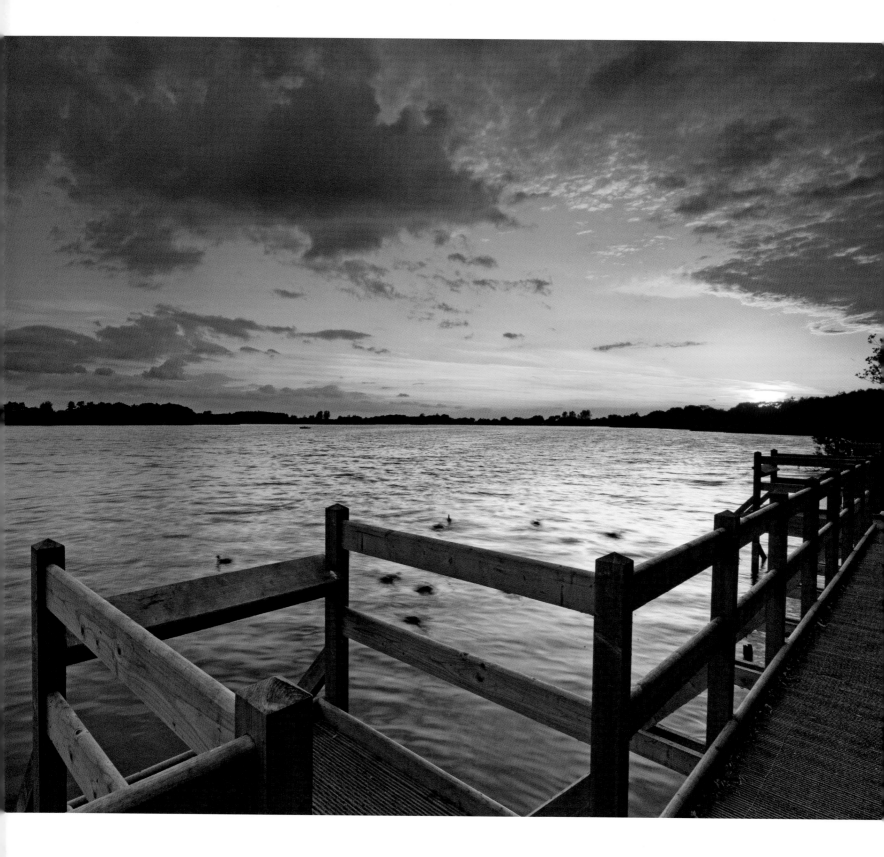

A beautiful sunset at Filby Broad taken from a boardwalk that has been constructed to give people access to admire the views or to fish in the clear waters of the Trinity Broads.

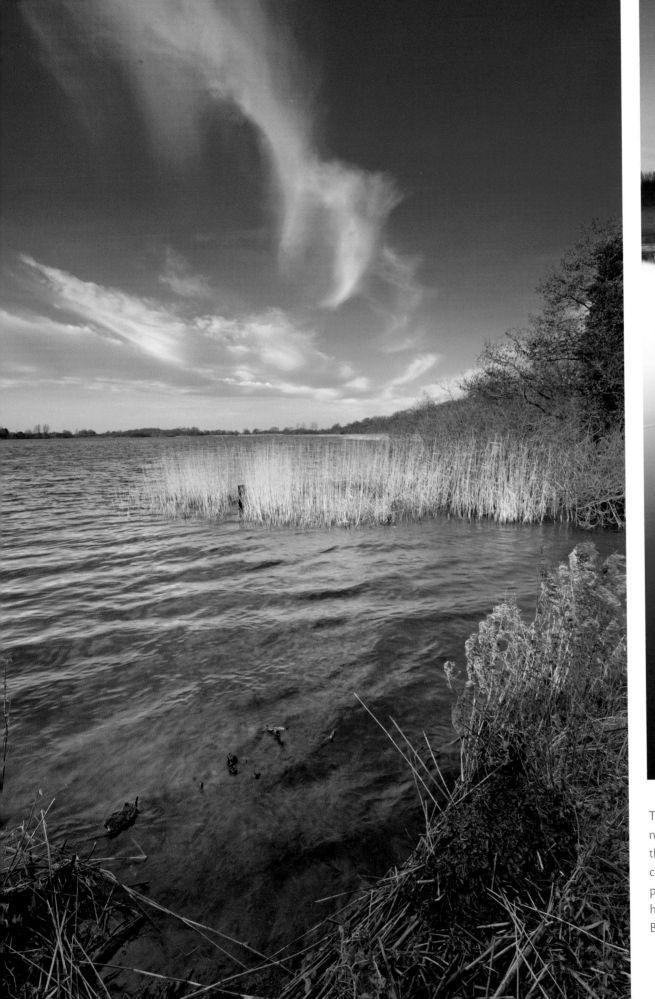

This view of Filby Broad is taken near the road bridge under which the nearby Ormesby Little Broad connects with Filby Broad. It is plain to see that the water quality here is much purer than the main Broads network.

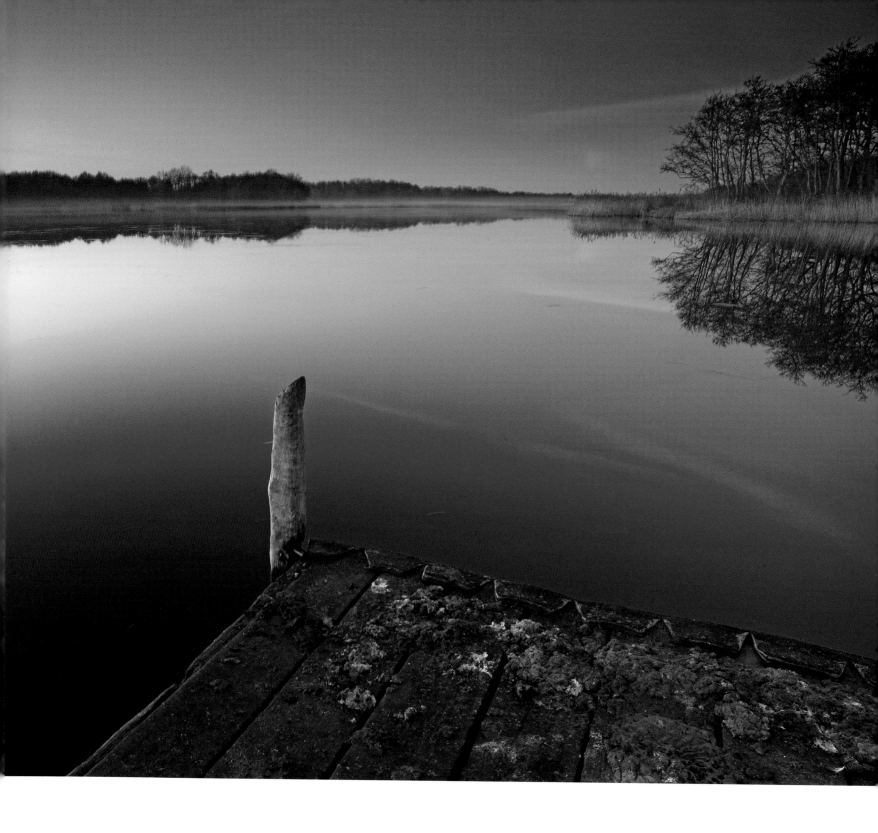

ABOVE Twilight at a calm Ormesby Little Broad with the reeds still managing to glow a beautiful golden shade in the fading light. This shot was taken at Filby on the southern part of the Broad.

OVERLEAF A wider view of the same pier at Ormesby Little Broad showing the boats that can be hired to take out on the Trinity Broads. No powered boats are permitted on the Trinity Broads.

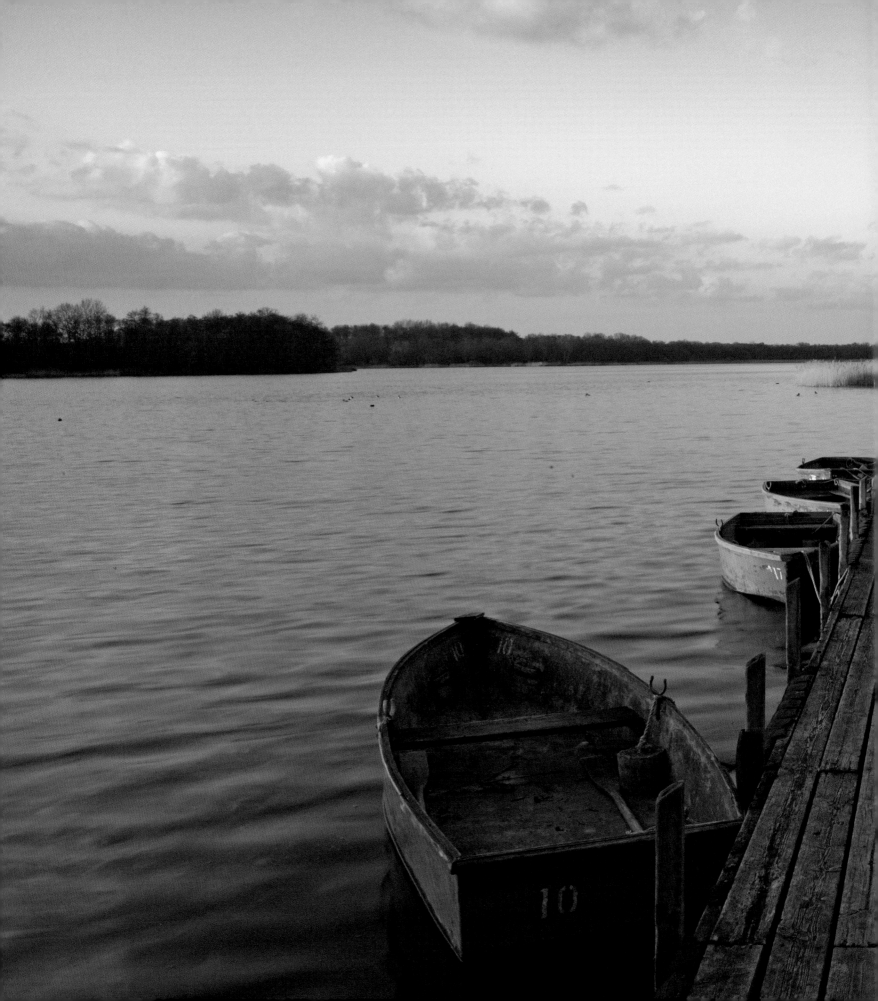

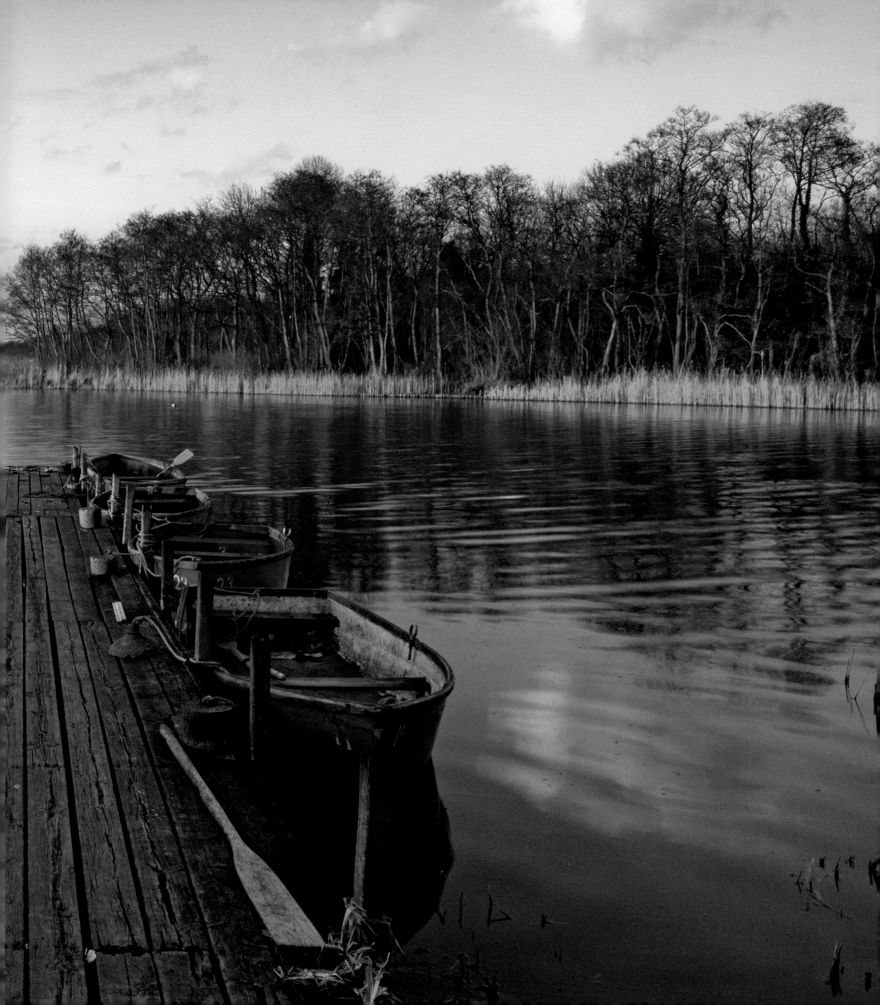

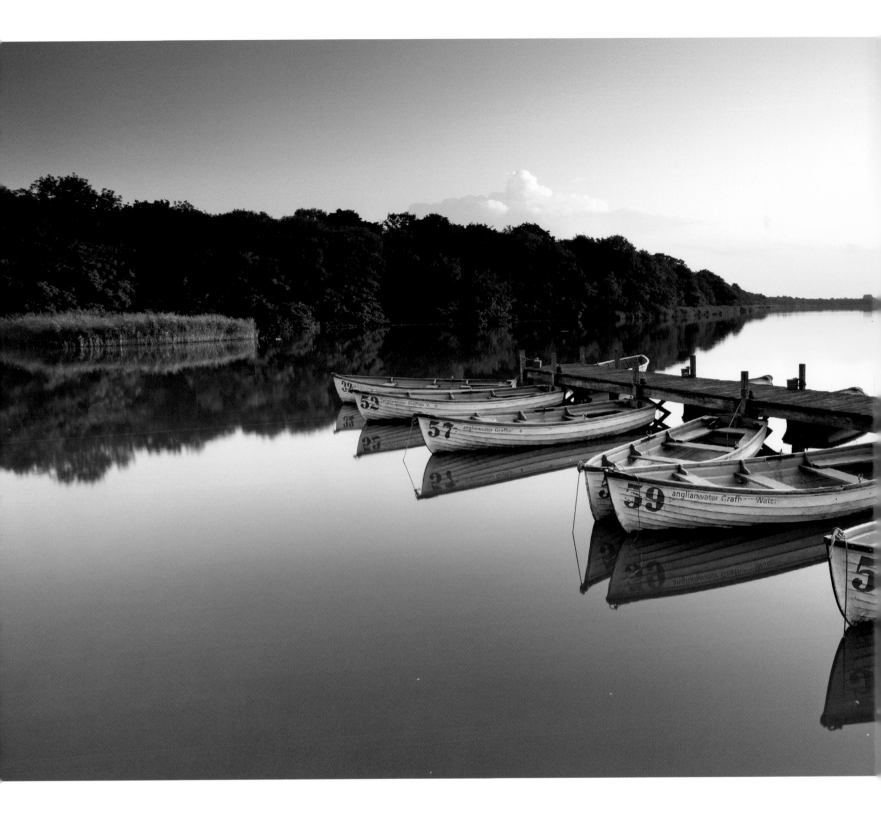

Ormesby Little Broad taken from the grounds of one of the nicest situated pubs in Broadland, the Eel's Foot Inn at Ormesby St Margaret. The low summer sun illuminates a small island in the Broad while the rowing boats are moored for the evening awaiting the possibility of another perfect summer's day come the morning.

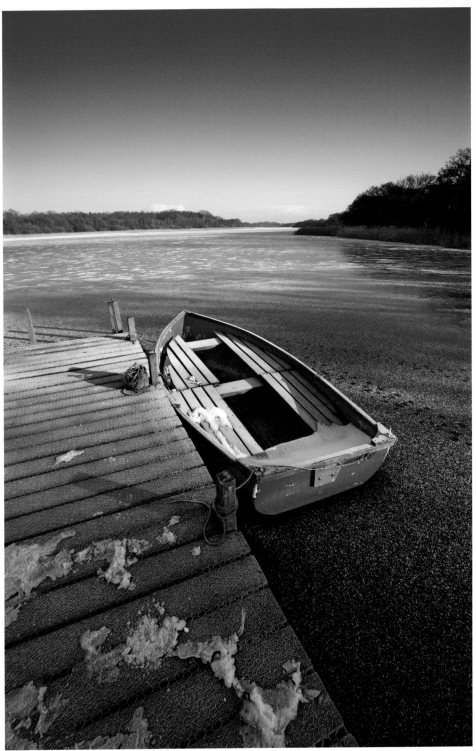

This is the only time I have ever witnessed one of the Trinity Broads frozen over. This view is of Ormesby Broad on a bitterly cold but beautiful late winter day.

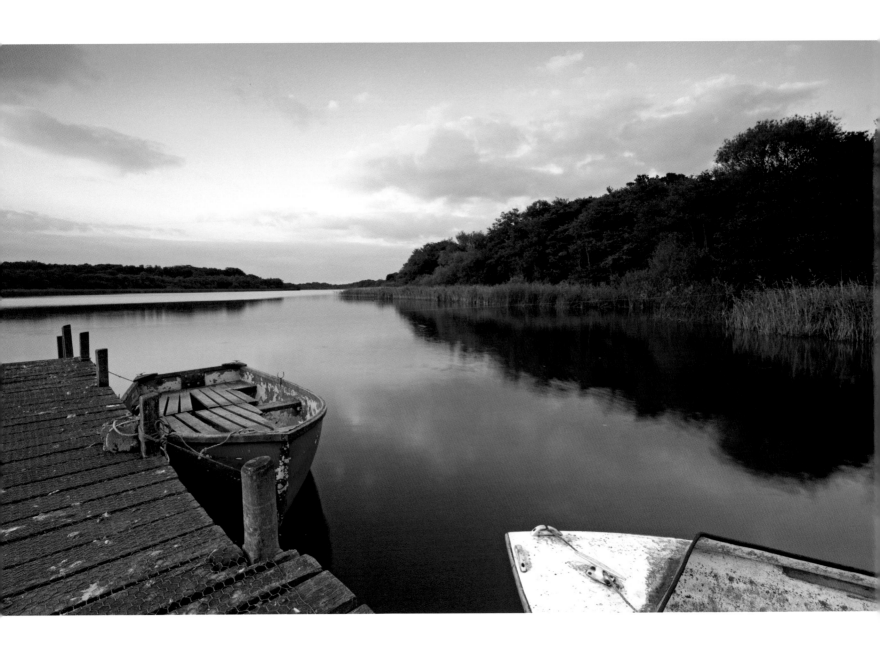

Ormesby Broad again but this time in much warmer
conditions on a balmy late summer evening.

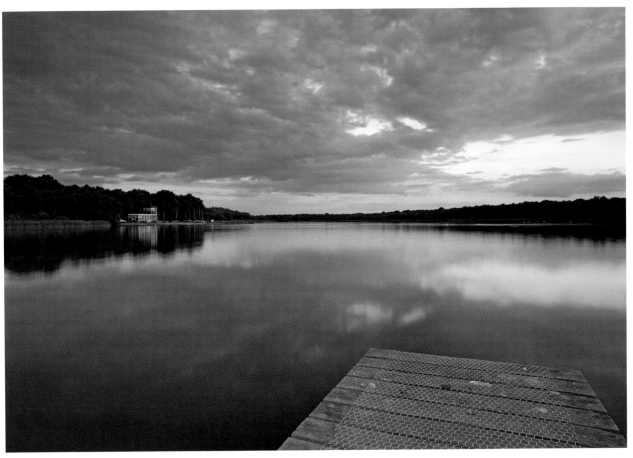

Rollesby Broad is one of my favourite broads to photograph. In this view the Rollesby Broad Sailing Club's headquarters can be seen on the left hand side of the picture. This is a perfect spot to view a dramatic winter sky reflected in the calm waters.

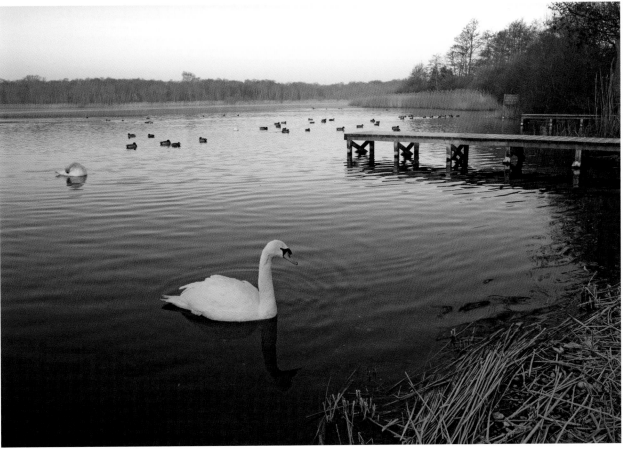

A swan glides towards the bank of Rollesby Broad near to the small piers used for fishing.

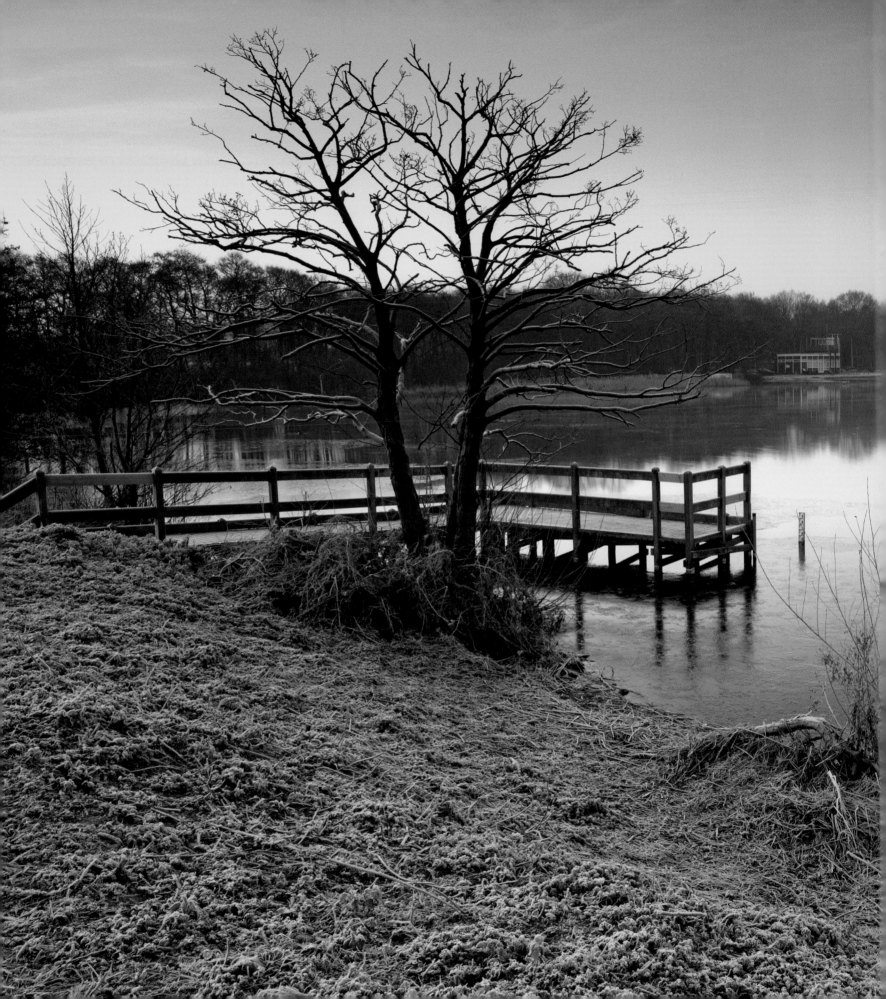

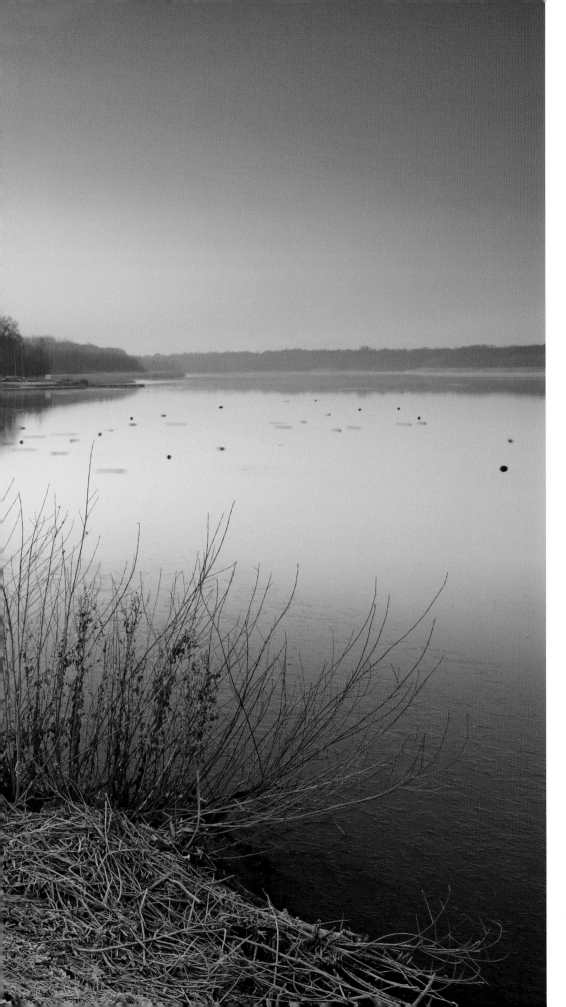

A frosty morning with beautiful shades of red and blue in the sky on the banks of Rollesby Broad.

ACKNOWLEDGMENTS

I would like to thank the following people for their help and support with my photography and the publishing of this book:

Stef, Ione, Jasmine and Cameron; Mum, Dad and Tubs; Colin and Jenny, John Nicoll, Gareth Hacon, Curt Armer, Adam Burton; the Painting with Light Society a.k.a. Dave, Ian, John, Chris H., Chris C.J., Chris S. and Katie; Gemma Walker, Diana Leppard, Charlie Waite, Brian Wells, Richard Buckland, Jonny Worden; N.W.E.S. at Great Yarmouth and to those who have sent me emails with their kind comments about my work.

Further examples of my photography of the UK and beyond can be viewed at my website: www.jon-gibbs.co.uk where images are for sale as fine art prints. You can also contact me via the website regarding commissions and photographic workshops.

I would like to highlight the great work by the following organisations who help to make Broadland a special place to visit:

Norfolk Wildlife Trust	www.norfolkwildlifetrust.org.uk
Broads Authority	www.broads-authority.gov.uk
Norfolk Wherry Trust	www.wherryalbion.com
Wherry Yacht Charter Charitable Trust	www.wherryyachtcharter.org
Hunter's Yard	www.huntersyard.co.uk
Norfolk Windmills Trust	www.norfolkwindmills.co.uk
English Nature	www.naturalengland.org.uk
RSPB	www.rspb.org.uk
National Trust	www.nationaltrust.org.uk
Ted Ellis Trust	www.wheatfen.org
English Heritage	www.english-heritage.org.uk

A view of Limpenhoe Mill and a 'sea' of reeds beside the River Yare.

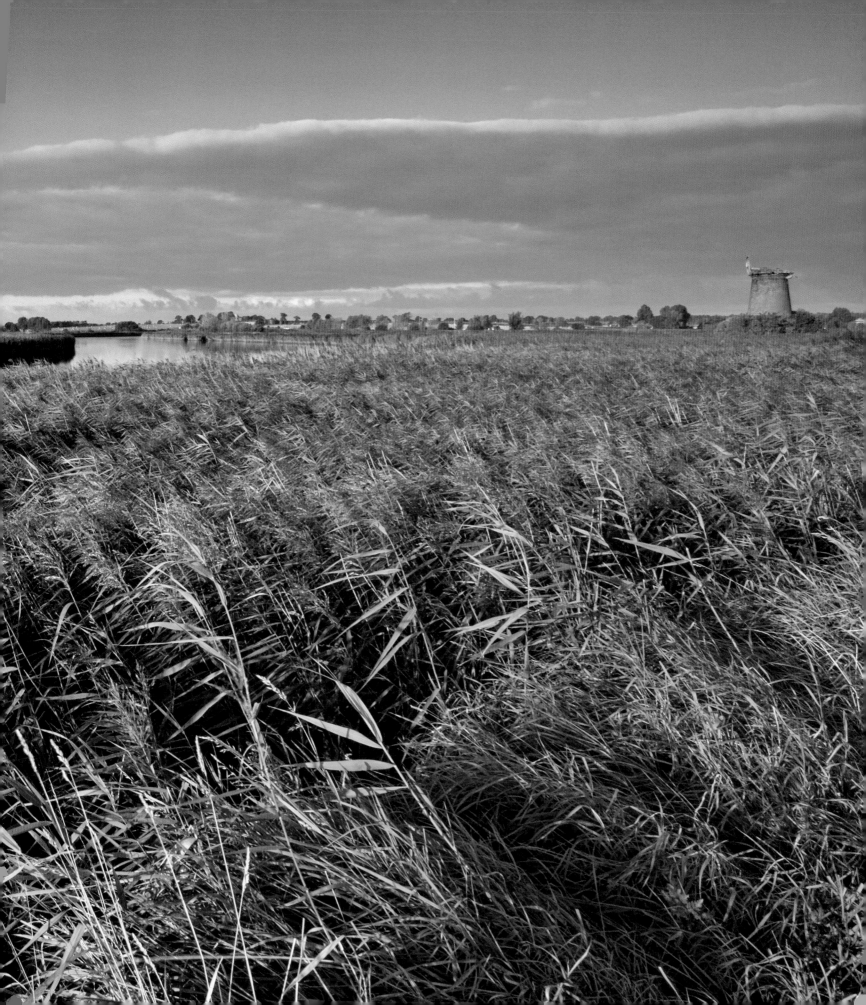

INDEX